BEARDSLEY
and his world

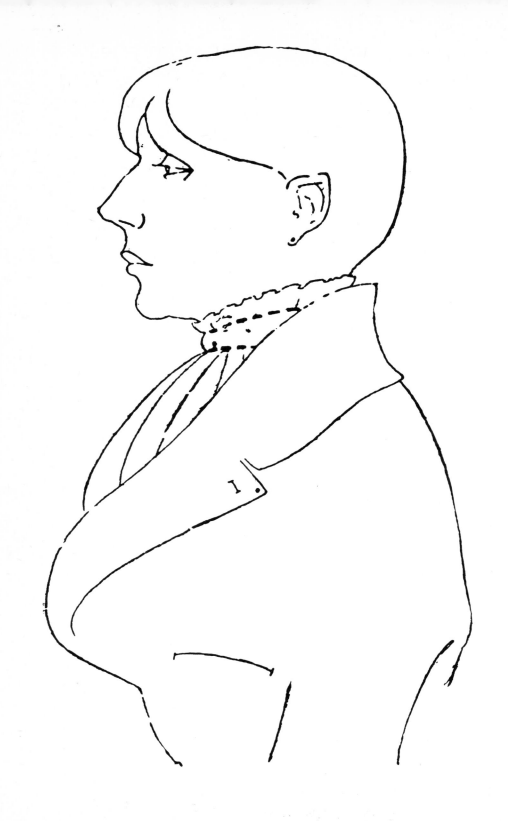

BRIGID BROPHY

BEARDSLEY

and his world

THAMES AND HUDSON
LONDON

(*Frontispiece*) A Beardsley self-portrait, published in 1896.

Printed in Great Britain by
Jarrold and Sons Ltd, Norwich

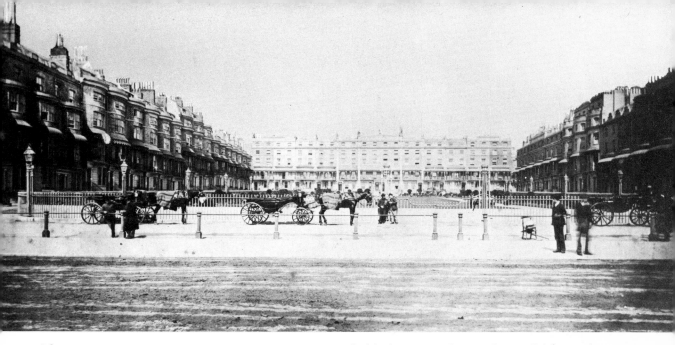

MIDDLE-CLASS ENGLAND IN THE 1870s was probably the most inhibiting and philistine environment a great artist could be born into.

As a child, Beardsley had not yet discovered that his chief talent was for drawing, rather than for literature or music, where he was also gifted. But he early guessed he might be great at *something*. His hand in his mother's, after his parents had taken him to a service in West-minster Abbey, he asked: 'Mummy, shall I have a bust or a stained-glass window when I am dead? For I may be a great man some day.' (His mother asked which he would prefer, and he opted for 'a bust, I think, because I am rather good-looking'.) He also early knew that 'when I am dead' was likely to be soon. He was seven when he first, in his mother's words, 'showed signs of tuberculosis' – for which at that period no cure was known. He lived his adult life in dread of immediate death and in a terrible artistic hurry: to discover his proper medium and create his individual style (both of which proved revolu-tionary in their effects) and then simply, in obedience to his imagina-tion, to create – in time.

As it turned out, he died at twenty-five. His genius *was* fulfilled: but only just. He only just had time. Circumstance, which forced haste on him, did him one good turn that helped him move quickly. It was a tiny but pure, blessed and possibly indispensable stroke of good fortune that the town where he was born and, for the most part, brought up was Brighton. Quite conceivably that seaside town in Sussex was the only place in Europe that could, at that particular period, have delivered the right stimulus, with enough force, to his imagination.

Regency Square, Brighton. The architecture dates from 1818, the photograph from the eighties, when Beardsley was living in the town.

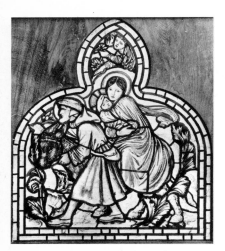

As a boy, Beardsley could have seen works by Edward Burne-Jones at Brighton, including this stained-glass window (*The Flight into Egypt*) in the church of St Michael and All Angels.

(*Opposite, above*) The Dome (the Royal Stables), Brighton, built by Porden between 1801 and 1805. In the 1880s Beardsley performed here in school entertainments.

(*Opposite, below*) Max Beerbohm's *George the Fourth*, published under Beardsley's editorship, was part of his attempt to rescue the reputation of the king and his buildings from Victorian disapproval.

During his boyhood there, Beardsley no doubt believed that the aesthetic education Brighton offered him consisted in the fake medieval beams of the Anglo-Catholic church he frequented or in the Pre-Raphaelite glass of the church of St Michael and All Angels. His early attempts to break free from Victorianism were mimicries of the Pre-Raphaelite rebellion, which had already grown respectable and which to a modern eye (whose criterion of 'the modern' is fixed partly by Beardsley) looks quite as quintessentially Victorian as the academicism it rebelled against. The Pre-Raphaelites were quintessential Victorians in their likeable but artistically sterile conviction that social fervour, good moral intentions, hard work and literal-minded honesty would do as substitutes for talent.

The influence of Brighton did not become visible in Beardsley until after he had grown up and left the town. Suddenly, and seemingly without preparation, he stopped being a late Pre-Raphaelite and became pure Beardsley. At twenty he claimed, correctly, to have 'struck out a new style and method of work' that were 'quite original'. He was writing to, poetically considered, the right person: the headmaster (who had been Beardsley's headmaster) of Brighton Grammar School. The essence of his 'new style' was what he had read direct from the terraces and crescents of Brighton.

The Beardsley style dispensed with the Pre-Raphaelites' reliance on displaying the dignity of labour through the artist's laboriousness. It relied on nothing but talent. It asserted the artist as aristocrat, insolently placing a line in an area, an ornament on a surface, at what his imagination unarguably decreed to be the right place.

Like the town of his birth, Beardsley's art was forceful, elegant, stylish – and a touch raffish. The tinge of scandal that had attended Brighton ever since it became the home of Mrs Fitzherbert, the loved but unconstitutional wife of George IV when he was Prince of Wales, and the site of the king's own most beautiful but most impolitic extravagances, attached itself to Beardsley. The philistines of England did for him the one service philistines can do for artists: they were shocked by him. Their shock made him rapidly famous or at least notorious, though it didn't assure him of a livelihood. All his adult life or, more exactly, throughout his long dying, as his illness ate into the amount of work he could do, he was in a panic lest pauperdom catch him before death should.

Besides its splendid domestic architecture, Brighton possessed, and impressed on Beardsley's imagination, two incomparable, bizarre and palatial masterpieces: the Dome, which William Porden built, as the Prince of Wales's stables, between 1801 and 1805 and which contemporaries likened both to a Turkish mosque and to 'the buildings of Hindustân'; and the Royal Pavilion, to which John Nash imparted its almost inconceivable final shape ('Moorish, Tartar,

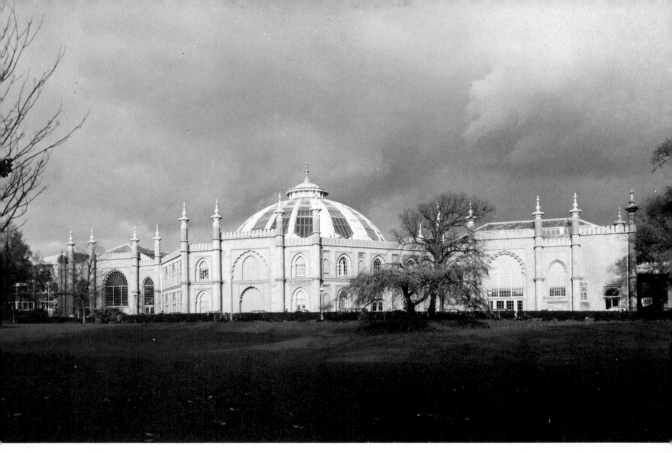

Gothic and Chinese', according to Princess Lieven) between 1815 and 1821, at the command of, as he successively became, the Prince Regent and King George IV. As a schoolboy Beardsley knew both buildings, inside as well as out. At a period when many respected artists were labouring after truth to nature or truth to this or that historical or geographic style (which meant, in effect, trying to make an authentic fake), Beardsley learned, from these two caprices of eclectic exoticism, the lesson of truth to the imagination.

Perhaps the regal impresario who commissioned the buildings became a personage in Beardsley's mental world. He seems, curiously but not incongruously, to lurk in Beardsley's images of Oscar Wilde. Beardsley's Wilde is essentially the same figure as the caricature of George IV (which Beardsley, as art editor of *The Yellow Book*, published) by Beardsley's friend Max Beerbohm.

Certainly the buildings themselves became part of the baroque furniture of Beardsley's mind. At twenty-four, isolated (in hope of health) on another part of the coast, he wrote to the friend who provided him with books: 'If there *is* such a thing as an illustrated account of the Brighton Pavilion I should love to have it.' A sentence later

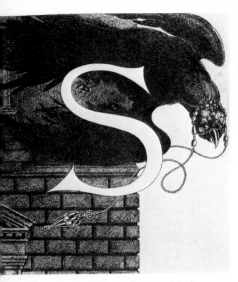

An initial letter for Beardsley's planned edition of *Volpone*. At the end of his life he created a baroque style of his own, partly from memories of the Royal Pavilion.

(*Opposite*) The Banqueting Room (from Nash's *Views* of the Pavilion). 'Embellished', according to an account of 1838, 'in imitation of Japan work', it perhaps helped to prompt Beardsley's 'new style' of 1892 'founded on Japanese art'.

he added the explanation: 'I ask for the book on the Brighton Pavilion in order to get help for some architectural backgrounds I have been thinking of.'

The architectural backgrounds seem to be among the things he didn't have time to do. But the interior architecture of the Pavilion was lodged in his imagination, and it furnished the baroque illustrations that he drew, in the last months of his life, for a projected illustrated edition of Ben Jonson's play (of 1605) *Volpone*. There is no mimicry. Beardsley was creating a new baroque: modern, personal and also tragic. *Volpone* itself, he wrote in his note on the play, intended for the publisher's prospectus, was more than satire: it 'might more fitly be styled a tragedy, for the pitiless unmasking of the fox at the conclusion of the play is terrible rather than sufficient'. Illustrating it, Beardsley transformed into tragedy the witty, pastiche but aesthetically serious baroque of the Pavilion. The great fairy-tale dragon that flies across the domed ceiling of the Pavilion's Banqueting Room is transmuted into a bird of prey, the bird of death; and about the bird's horrid brow Beardsley has draped one of the glittering, mock-precious ropes, ending in a solid tassel, that hang in swags from the Banqueting Room's chandeliers.

Brighton was able to show Beardsley the interiors of its two great buildings because the buildings by then belonged, in the literal sense, to Brighton. In 1845 Queen Victoria closed the royal household at Brighton. She stripped the interiors, down to the last fitting, and expected the Pavilion and its attendant buildings to be sold for demolition. It was 'the inhabitants of Brighton' who saved them. They petitioned Parliament; and, after a referendum among the Brighton ratepayers had (narrowly) approved the idea, an Act of Parliament of 1850 enabled the Town Commissioners to raise a loan from the Bank of England and, for a price of £53,000, become the owners of the Pavilion and its estate. The interiors were refurbished, and the many items of the moveable furniture that were not in use in other royal residences but merely standing about, still crated up, were piecemeal wheeled back from the queen.

In the fifties and sixties, the posthumous repute of George IV lay under a frown of moral disapproval, and the words *baroque* and *rococo* were terms of abuse, synonymous with 'in bad taste'. ('Grotesque' is one of the senses the *Shorter Oxford English Dictionary* assigns to *baroque*. The use of *rococo* it dates to 1844, with the sense of 'tastelessly florid or ornate'.) In that climate the ratepayers of Brighton, wittingly or unwittingly, acted as aesthetic pioneers. The fact that they prized the Pavilion, even if only perhaps as a curio with high-class historical associations, made Brighton unique in Victorian Britain and, probably, the sole place that could have instructed Beardsley's eye and imagination in time.

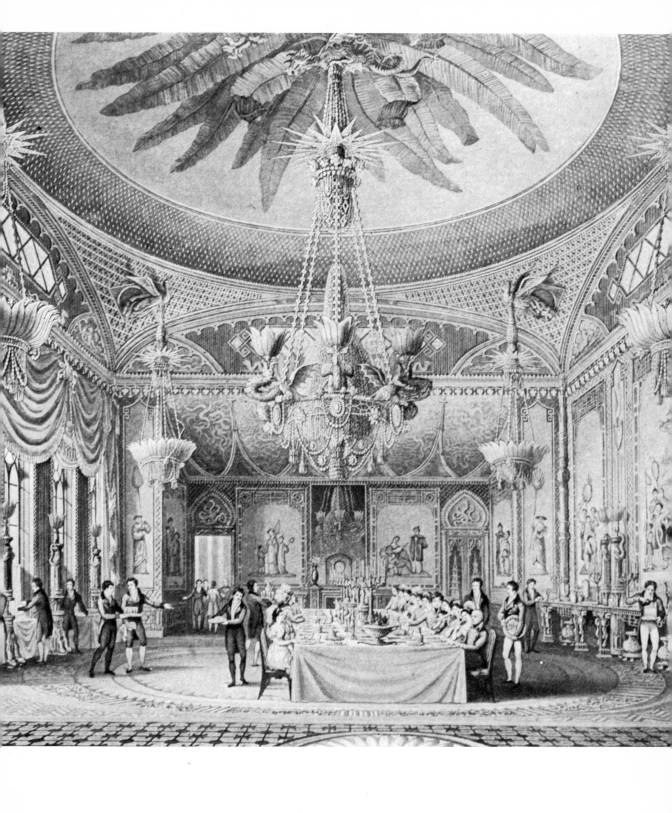

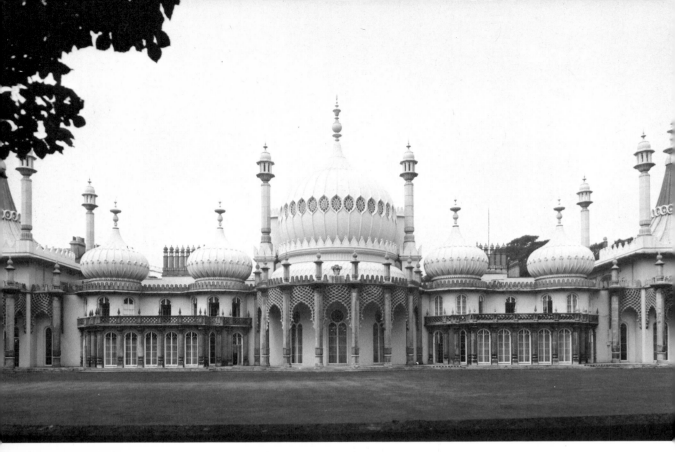

The 'cheeky minarets' (as they were called by Beardsley's friend Max Beerbohm) of the Royal Pavilion.

The Banqueting Room (as it is now) in the Royal Pavilion, Brighton. When Beardsley knew it, it was already being refurbished after its spoliation by Queen Victoria.

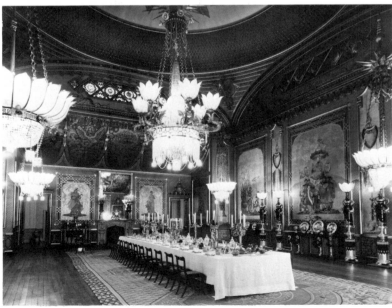

The newly bought Pavilion was opened to the public, with a grand ball, in 1851. Thereafter it was regularly open to paying customers – who, from 1863 on, got increasing value for their money as Queen Victoria was persuaded to return the furniture, including the chandeliers and the great dragon of the Banqueting Room. Both Pavilion and Dome were used for such communal, local purposes as parties and entertainments given by Brighton Grammar School. Several such occasions gave Beardsley the chance to fix in his mind the decoration of both. He saw the Pavilion, moreover, in tolerably authentic Georgian condition – an opportunity that vanished (until the recent restoration) in 1898–9 under repainting and a layer of chocolate-coloured lincrusta.

In the Pavilion gardens in the nineties, a band played by night. Max Beerbohm mentions it in his essay, written at Brighton, in the cause of rehabilitating George IV. The essay accompanied his caricature of the king in *The Yellow Book* of October 1894. Lamenting the destruction of George IV's other great architectural monument, Carlton House, Beerbohm wrote: 'I am glad that the Pavilion still stands here in Brighton.' Playing on his classical scholarship to indicate, through his literal Latin use of *trite*, that the town council kept the grass close-mown, he added an acknowledgement of his own aesthetic education that Beardsley must have endorsed: 'Its trite lawns and cheeky minarets have taught me much.'

BY A STROKE OF POETIC JUSTICE, it was in the gardens of the Pavilion, with their municipally trite lawns, that the people who were to become Aubrey Beardsley's parents conducted their courtship.

They were Vincent Paul Beardsley and Ellen Agnus Pitt.

It was Ellen Pitt who lived at Brighton, where the Pitts were a medical family. Her grandfather, Thomas Best Pitt, practised medicine there during Brighton's Regency vogue as a health resort. Her father, William Pitt, who was born on 6 September 1816, combined medicine with British imperialism. He made his career in the medical service of the Honourable East India Company, the commercial, private-enterprise and yet official administrative arm of British rule in India. He was stationed chiefly in Bengal, which was already part of the British Empire, and he took part in the war of 1852 which annexed Lower Burma to it.

In Bengal William Pitt met and married Susan Lambe, daughter of a Scottish indigo-planter. Ellen, their middle daughter of three, was born in Bengal on 28 August 1846. Her second name, Agnus, sometimes defeated officials who had to record it in documents, where it is liable to appear as the conventional Agnes. It was in fact a pun, *agnus* being the Latin for 'lamb'. Her maternal grandfather, Alexander Imlach Lambe, wanted the baby named after him.

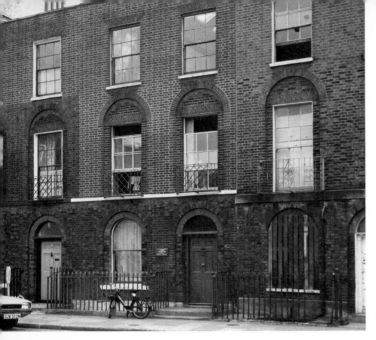

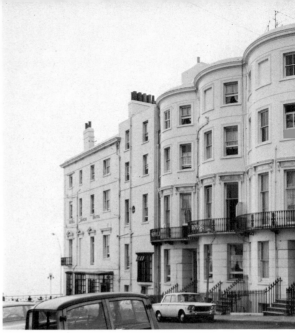

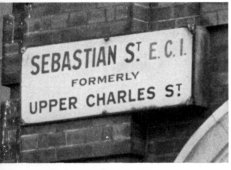

(*Top*) The home of Beardsley's paternal grandfather, Paul Beardsley, a goldsmith: 9 Sebastian Street, Clerkenwell, London.

(*Above*) When Paul Beardsley had his home there, Sebastian Street was called Upper Charles Street.

(*Centre*) Eaton Place, Brighton. No. 9 was Beardsley's father's address at the time of his wedding, though he came from London.

(*Top right*) The home of Beardsley's grandfather, William Pitt: 31 (then numbered 12) Buckingham Road, Brighton. Mabel and Aubrey Beardsley were born here.

William Pitt retired (in September 1859, when he was forty-three and his daughter Ellen Agnus was thirteen) with the now obsolete rank of Surgeon-Major and medals to commemorate his service in Burma and during the Indian Mutiny. He took a job on the Channel Island of Jersey before returning to, and settling in, Brighton.

His middle daughter was considered in Brighton the liveliest of the Pitt sisters. But she carried liveliness beyond the middle-class bounds and provoked, according to her later recollection, 'scandal-mongering' when, without introduction, she made the acquaintance of Vincent Beardsley 'on Brighton pier' (*which* of the two piers Brighton then possessed neither she nor scandal recorded) and took to meeting him in the Pavilion gardens clandestinely.

It is sadly easy to guess that Vincent Beardsley, a Londoner, was in Brighton in pursuit not only of girls but of health. He was consumptive. His father, Paul Beardsley, had died of consumption at the age of forty, when Vincent was five or six. Paul Beardsley had been a manufacturing goldsmith. He lived in a pretty, terraced house, which still has a studio roof designed to admit light for the practice of craftsmanship, at 9 Upper Charles (now renamed Sebastian) Street in Clerkenwell, just to the north-west of the City of London. His son Vincent was, at the time of his marriage, without occupation. In the space in his marriage registration for 'Profession or Rank', he had the Registrar enter a rank: 'Gentleman' – which meant, in the jargon of the period, that he had no need to earn a living.

Indeed, at the age of about nineteen, he had inherited, by will, a legacy of £350 and a quarter of the estate (which, before various

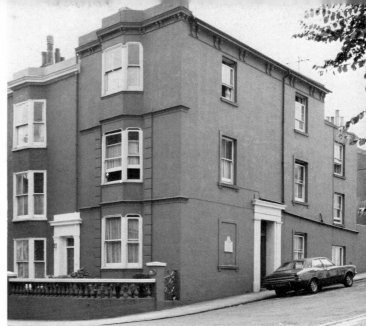

legacies were taken out of it, was worth £3,000) of his maternal grandfather, a Welshman living in London, David Beynon. The will was obviously designed to make provision for a fatherless child in bad health. It had also some less obvious and by now inscrutable intention: Vincent Beardsley's inheritance came to him on condition he did not 'intermeddle with' his 'late father's estate'.

Vincent Beardsley was thirty-one and Ellen Pitt twenty-four when they married on 12 October 1870 – during a storm so intense that the wedding party gave up their plan to enter the church by the south door and instead used the vestry entrance on the north side, where they could step under cover as soon as they left their carriages. At the time of the wedding Vincent Beardsley was living or, more probably, lodging in Eaton Place, a handsome street of bulging, terraced houses running down to the front, in a district of Brighton where he had probably stayed as a tourist. The Pitts' home was on the hills behind the front: in that newer part of the town, to the west of the station, whose chief thoroughfare, running north-west inland, is Dyke Road.

Off Dyke Road, at 12 (now re-numbered 31) Buckingham Road, Surgeon-Major Pitt had a three-storey corner house that looks as if it might have been new-built in the sixties, at the time when, returned from India and Jersey, he must have been looking for a home to settle his family in. His daughter married Vincent Beardsley at the Anglican church of St Nicholas of Myra, in the next street to Buckingham Road and a little down the hill, though not far enough down to escape the October storm.

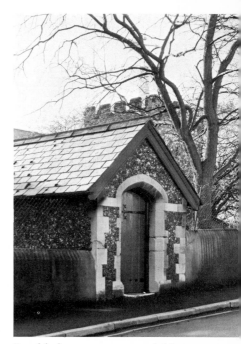

Beardsley's parents were married in 1870 in the church of St Nicholas of Myra, Brighton, during a storm so severe that the bride entered by the vestry door (shown here) to avoid crossing the open churchyard.

13

According to R. A. (Rainforth Armitage) Walker (who published also under the name of Georges Derry), the painstaking memorialist of Aubrey Beardsley and researcher into his ancestry, the Pitt parents at first opposed the marriage. Walker's information clearly came, some fifty years afterwards, from Ellen Beardsley. If there was, in any serious sense, opposition, it was withdrawn: Ellen was married from her family home and both her parents were witnesses to the ceremony. It looks as if this point, which is evident from the marriage certificate, occurred to R. A. Walker and was put by him to Ellen Beardsley. It is probably her explanation that is embodied in Walker's footnote to the effect that the marriage took place after Vincent Beardsley had 'won over' the Surgeon-Major 'to his side'.

Having indicated to Walker that her marriage was romantically carried through in defiance of opposition, Ellen Beardsley seems to have gone on to hint that it was a marriage romantic also in its social nature – that it was, in fact, a *mésalliance*: of wellbred woman and son of a craftsman.

It is true that the Pitts had social pretensions. Through the fact that Ellen's father was named William, though not through any precisely traceable lineage, they claimed kinship with the two prime-ministerial William Pitts, one of whom had been (as well as the founder of the imperial system that provided Surgeon-Major William Pitt with a career) an earl. It is also of course true that there were strong and cruel Victorian snobberies against people 'in trade' (which, presumably, a manufacturing goldsmith counted as being). No doubt it was with an echo of his mother's tone that Aubrey Beardsley, earning his living at sixteen as an insurance clerk, used the inverted commas and capital letters of self-depreciation to declare: 'I have been "In Business" since new year's day.'

However, the Victorian snobberies cut many ways. To Vincent Beardsley, coming from London, the society of Buckingham Road, Brighton, may well have seemed provincial. And on a financial computation, the type of computation by which marriages were regularly judged, it was unquestionably he who, on the wedding day, was entitled to think of himself as getting the poorer bargain.

It seems likely, therefore, that Ellen Beardsley added a little by fantasy to the social heights from which she stooped to marry. That would be in keeping with the cast of her imagination, which inclined backwards and upwards. She seems to have had a tenderness for the exiled royal house of the Stuarts; she claimed that her family nanny was a descendant of the sea-captain who carried Charles II to safety in France. Her politics were High Tory, as she incidentally disclosed in an anecdote she related (and R. A. Walker recorded) to illustrate the early self-possession of her daughter Mabel. Mabel, as a small girl, was invited alone ('They wouldn't have Aubrey; they thought he

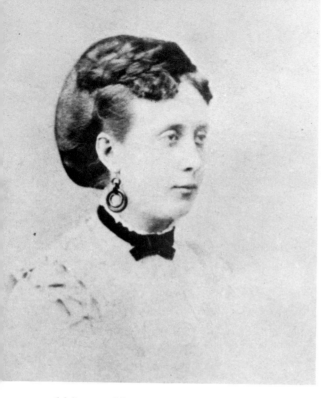

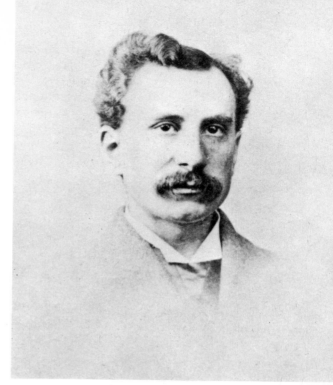

(*Left*) Beardsley's mother, Ellen Agnus (Pitt) Beardsley. Her second name, Agnus, was a Latin pun on her mother's family surname, Lambe.

(*Above*) Beardsley's father, Vincent Paul Beardsley. Beardsley was given the second name Vincent after his father, who in turn bore the second name Paul after *his* father.

would be troublesome,' Mrs Beardsley explained) to luncheon with grown-up friends of her mother's. The friends were radicals, according to Ellen Beardsley, in whose vocabulary, it emerges, even a Liberal was a radical. During luncheon, they bade Mabel look at a picture on the wall behind her. It was a picture of W. E. Gladstone. 'Those are not my Mother's politics,' Mabel said. (I surmise, by the way, that Gladstone was invoked during luncheon because the adults were enjoining on the child the advice he is widely believed to have given, to chew each mouthful many times.)

The notion that the Beardsley marriage was a *mésalliance* was accepted by Walker because his own researches confirmed the Beardsley side of it. The Beardsleys had been, he established, independent craftsmen whose family connections were lower-middle-class. The London Welshman David Beynon had been an innkeeper in Kentish Town, and one of the executors of his will, under which Vincent Beardsley inherited the private income that made him a 'gentleman', was a grocer. Ellen Beardsley's view of the social standing of her marriage must, however, have been independent of any facts about her husband's family, because that was a subject she knew little about and took no interest in. In 1920 she remarked: 'Aubrey had Welsh blood in him. His grandmother was a Beynon, but I do not know anything about the family. I destroyed several Beynon wills

and other papers a little while ago. I myself have a little Irish in me, and a little French.'

Between her statements, which Walker wrote down verbatim from memory, one can supply his genealogical and document-seeking questions. At the same time, one overhears her impatience with his concern for fact – and his shock, which she perhaps provoked deliberately, at the thought of a woman who would destroy family wills. She and he were inevitably at cross purposes because, although he noted that she had 'a quick and witty tongue', which 'was inherited by her son', Walker seems not to have recognized that hers was a tongue that sought to communicate not the literal facts of situations but what she took to be the dramatic essence.

It was the same faculty, sharpened, in Aubrey Beardsley that led many of his contemporaries to take in its literal sense what Bernard Shaw more shrewdly recognized as his 'boyish' pose of being 'a diabolical reveller in vices of which he was innocent'.

Where she was the only witness, R. A. Walker (and other scholars in his wake) took Ellen Beardsley's testimony literally. Where there was hope of documentation to confirm her, he went in search of it – and often ended puzzled. In the matter, for instance, of the Jacobite-descended nurse, he pursued a clue he found in a letter written by Ellen Beardsley in 1916 (and presumably shown to Walker by the recipient). Mrs Beardsley named the nurse as 'old Mrs Pendrill', said she had been both her own nurse and Mabel's, and asked her correspondent for a copy of the inscription on the tombstone of the nurse's sea-captain ancestor in the churchyard of St Nicholas's in Brighton (the Pitts' local church and the one where Ellen was married). Walker went in search of the tombstone. He found it not in the churchyard but in the chancel, and found that the sea-captain's name was not Pendrill but Tettersell. He surmised that Tettersell might have been old Mrs Pendrill's maiden name. (Strictly, he needed to surmise also that Mrs Pendrill, who presumably came of a Brighton family, had been summoned from Brighton to Bengal, there to nurse the infant Ellen Pitt, and had then returned to Brighton, where she later nursed the infant Mabel Beardsley.) Walker was bothered, however, by discovering that Penderel *was* the name of someone who rescued Charles II – not, however, by sea but on dry land; and he felt forced to wonder whether Mrs Beardsley was confused or whether her nanny was related to *two* Charles II rescuers.

Walker recorded Ellen Beardsley's claim to 'a little Irish' and 'a little French' blood without comment. His own researches, however, turned up nothing of the Irish, and the nearest he came to the French concerned not blood but language. He discovered, from family photographs and, probably, Mrs Beardsley's glozes on them, that the Surgeon-Major had worked in Jersey and that the family had been in

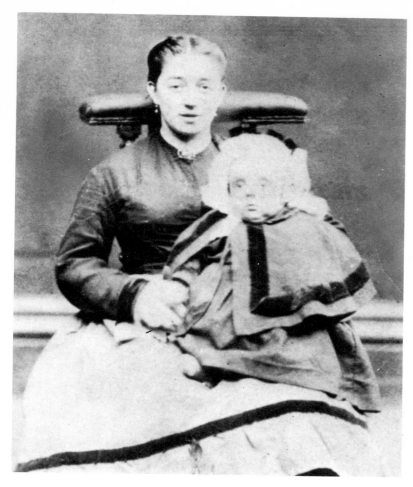

Aubrey Beardsley on his nanny's knee. His mother later claimed that the nanny who appeared in the earliest photograph of him was French.

the habit of visiting Dieppe. In those two places, Walker conjectured, the Pitt girls learned to speak good French. He then explained Aubrey Beardsley's 'uncanny knowledge of French which has astonished many critics': it was learnt partly from his mother; and, in addition, the earliest photograph of Aubrey showed him 'on the lap of a French bonne'. The identification of the nurse in the photograph came, presumably, from Mrs Beardsley. And, presumably, between the nursemaiding of Mabel and, a year later, the nursemaiding of Aubrey, 'old Mrs Pendrill' had retired.

If Ellen Beardsley did dramatize, among other things, the social gap between herself and her husband, her fantasy may have dated from the time of the marriage (which she perhaps construed as one of those marriages fashionable in the British aristocracy where high breeding was fair exchange for vulgar money) or it may have been evolved later by way of consolation for her disappointment in the

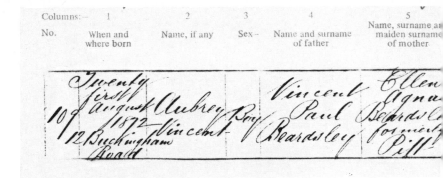

Columns:—	1	2	3	4	5
No.	When and where born	Name, if any	Sex	Name and surname of father	Name, surname and maiden surname of mother
10	Twenty first August 1872 12 Buckingham Road	Aubrey Vincent	Boy	Vincent Paul Beardsley	Ellen Agnes Beardsley formerly Pitt

AUBREY BEARDSLEY
Master of Line
WAS BORN IN THIS HOUSE
ON AUGUST 21ST 1872
HE WAS A PUPIL AT THE
BRIGHTON GRAMMAR
SCHOOL 1884–1888
AND DIED AT MENTONE
ON MARCH 16TH 1898

The plaque now beside the front door (which is in West Hill Place) of 31 Buckingham Road, Brighton.

marriage. All that is certain is that she was disappointed and that her disappointment was at least partly financial.

By one account Vincent Beardsley lost his money on his very honeymoon – and in a manner that must have affronted his bride's dignity. He was threatened, by a clergyman's widow, with a suit for breach of promise to marry. By Walker's (that is, presumably, Ellen Beardsley's) account, the Pitt family insisted on his avoiding scandal, so he settled the case before it could come to court, raising the money to pay the damages by selling some house property in the Euston Road, London. By another account, which Walker rather desperately remarked need not be incompatible with the first, since Vincent Beardsley might have squandered his fortune in two instalments, it was when she came downstairs for the first time after the long bout of puerperal fever she suffered after Aubrey's birth that Ellen Beardsley was told that her husband had lost all his money.

The stairs she came down were in Buckingham Road, Brighton. The newly married Beardsleys seem to have taken up lodgings in London, but both their children were born at Ellen's father's house at Brighton: Mabel on 24 August 1871; and Aubrey Vincent on 21 August 1872.

The choice of birthplace was no doubt a sign that the Beardsleys had not established a permanent home of their own – and perhaps also that Ellen preferred to think of her father's household as home, though she allowed her son to be given the second name Vincent after his father.

The stories of Vincent Beardsley's losing his money place Ellen Beardsley melodramatically in the role of martyr. First she is the innocent bride, whose husband turns out, woundingly and costlily, to have flirted with another woman; then she is the suffering mother whose husband dissipates a fortune while she is ill in childbed. Perhaps they are dramatizations of the wounding discovery that Vincent Beardsley had less money than she had supposed. It might well be that an income large enough to keep a bachelor in the position

6	7	8	9	10*
Occupation of father	Signature, description and residence of informant	When registered	Signature of registrar	Name entered after registration
Gentleman	Vincent Paul Beardsley Father 12 Buckingham Road Brighton	Sixteenth September 1872	Thorncroft Registrar	

Registration of Aubrey Beardsley's birth.

of 'gentleman' proved too small to support a wife of Ellen Beardsley's social tastes and a family.

Certainly, within a few years of the wedding where he professed himself a gentleman, Vincent Beardsley was obliged to take a job. By the time Aubrey was two or three, his father was working for the West India and Panama Telegraph Company. Walker traced him to two further jobs, both with brewery businesses in London (the New Westminster, of Horseferry Road, and Crawley's, of Vauxhall). The second of these, Walker established, he held for at least six years – to the contradiction of the statement by later and less careful Beardsley scholars that he 'drifted from job to job'.

Ellen Beardsley later claimed that it was she who got him one of his brewery jobs. Even so, she further claimed, he didn't regularly support his family, and it was she who earned a living for herself and her two children. This she did by working as a governess and by giving lessons, including music lessons, piecemeal, her clientele being provided by rich and helpful friends. She worked long hours, sometimes giving evening lessons after a day's work, and, she told Walker, she was sometimes so poor that her only meal of the day was a penny bun and a glass of milk.

In her brief biographical account of Aubrey, written at an unknown date after his death and eventually (in 1949) published by R. A. Walker, Ellen Beardsley emphasized two items about his early childhood. The first was his physical fragility. He was, she wrote, 'like a delicate little piece of Dresden china'; and she added a memory of his once helping himself up a high flight of steps with a fern. Her second emphasis was on his musical precocity. Before he could walk he would crawl to the piano and listen, while he beat time with a toy building brick, 'to his mother's playing of a Beethoven Sonata'. In conversation, she added that he remained unbaffled even when she introduced deliberate changes of time to test him. At four, he enjoyed a symphony concert at the Crystal Palace. Soon he was himself playing Chopin at the piano 'as charmingly as anyone could wish'.

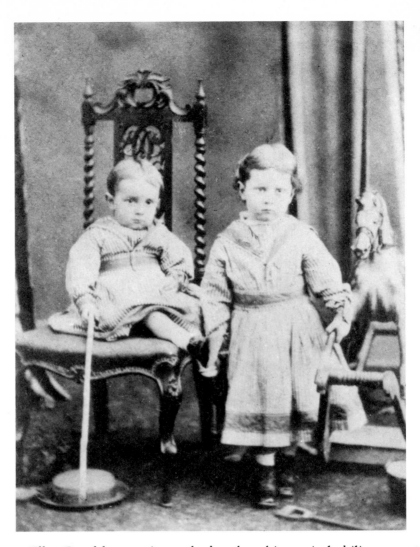

Aubrey Beardsley and his sister
Mabel. She was almost exactly a
year older than he was.

Ellen Beardsley was in no doubt where his musical ability came
from. 'This taste', she wrote, 'he inherited from his mother, a very fine
musician, the pupil of Dr Wesley.' (Of the many Wesleys recorded
in musical dictionaries because of their influence on English church
music, the likeliest to have been her teacher, though he was only some
four years her senior, is Francis Gwynne Wesley. He was a doctor of
music, which accords with the title her manuscript gives him. How-
ever, he was not a professional musician but a clergyman. Perhaps he
gave her lessons while he was himself a music student – before, in
fact, he became a doctor. Later, he was vicar of Hamsteels in County
Durham. Any lessons from there to Ellen Pitt or Ellen Beardsley
must surely have been by correspondence course.)

About music and, indeed, literature, Ellen Beardsley had intellectual pretensions; and she seems to have exercised her governessy spirit at home as well as at work, and on her husband as well as her children. It was to Vincent Beardsley, along with Mabel and Aubrey, that, she told Walker, she used to play six pieces an evening – from a book of programmes which she so designed that, without hearing anything too often, they should learn 'to know and appreciate the best music'. Apparently she was still speaking of all three when she added: 'I would not let them hear rubbish, and it was the same with books. I would not let them read rubbish.'

Perhaps one of the things that made Aubrey Beardsley give precedence to his talent for drawing over his other talents was that visual art seems to have been the only art about which his mother had little to say.

It was in keeping with her musical pretensions that she evidently told Walker that, when she first came to London, she (and, presumably, her husband, though he goes unmentioned) lodged with 'the parents of Landon Ronald'. Walker, after reporting her hint that Landon Ronald became 'Mabel's first beau', went on to conjecture that it was from that musical household that Ellen Beardsley gave music lessons, which she did to pupils who included the children of the German ambassador.

Landon Ronald was Melba's accompanist and, later, one of the most famous of British conductors; he specialized in Elgar and presently became Sir Landon. However, at the time when Ellen Beardsley came to London, he did not yet exist. (He was born in the year after Aubrey's birth.) Ellen Beardsley evidently chose not to explain to R. A. Walker who 'the parents of Landon Ronald' were. Landon Ronald in fact formed his professional name by dropping his real surname, which was Russell. The people whom Ellen Beardsley lodged with must have been known to her as Mr and Mrs Henry Russell. Henry Russell was indeed a skilled and trained musician. (He had been a pupil of Rossini.) Trading, however, on the highbrow musical reputation later acquired by his son, Ellen Beardsley failed to mention to Walker that Henry Russell made his living as a travelling entertainer singing his own compositions, which included 'Cheer, Boys, Cheer' and 'A Life on the Ocean Wave'. No doubt she considered them – or feared others would consider them – 'rubbish'.

Diagnosed tubercular, Aubrey was, at seven, sent to the country, to a boarding school for boys. (Mabel remained at home with their parents.) He probably began school in the autumn of 1879, at the beginning of an academic year, and by 1 October was reporting by letter to his mother: 'I am getting on quite well. The boys do not tease me.' After Guy Fawkes Day he reported that the boys had been allowed to have a bonfire and fireworks and to stay up late. He added

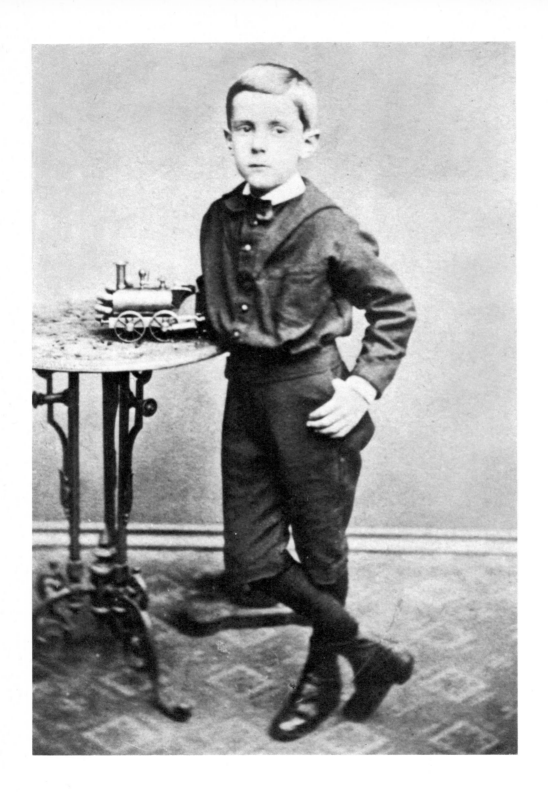

that he was 'quite well and happy', asked for some extra money, so that he could make the expected contribution to the expenses of the play performed at the breaking-up party, and, with his eye on his return home after the breaking-up, enquired: 'When is my engine going to be mended?'

The school, Hamilton Lodge, was at Hurstpierpoint in Sussex: close enough to Brighton for the pupils to be taken there, on day trips, to a circus and to a parade. It was run by a Miss Wise with the help of a Miss Barnett. Miss Barnett often sent her love to Mrs Beardsley by way of Aubrey's letters home, and at least once she let Aubrey enclose his letter with one that she was sending to Mrs Beardsley on her own account. It would be natural to guess that the two women knew each other, probably at Brighton, before Aubrey went to the school and indeed that their acquaintance determined the choice of the school. But Ellen Beardsley's account of Aubrey's school life mentions no such connection. What it does mention is a black episode which, it claims, was the start of Aubrey's 'stoicism': 'He was beaten by the schoolmistress to force him to cry, but he refused and she had to give in.'

Perhaps it is true. But it does not sound like the tenor of the school as Aubrey's letters home convey it, and his letters home (with the exception of an obvious form-letter that begins 'My dear Parents, Miss Wise wishes me to tell you that the holidays will begin on Saturday the 20th instant') do not sound censored or distorted by authority.

Between the school and Ellen Beardsley there was an inevitable conflict, on a subject near and dear to Ellen's image of herself: Aubrey's music. His musical development, she told Walker in 1920, was 'checked' when he went to school because there were no facilities for practice. She added the extra reason that at school he took up new interests, including drawing. Even so, her account is not quite borne out by Aubrey's letters home. A letter to his mother records: 'I have begun Music but I do not do much yet.' Then a letter to Mabel says: 'I am getting on much better with my music now. . . . I hope I shall begin a tune soon; if I am good perhaps I shall on Monday.'

It looks as though the school had found him less of a prodigy than his mother later claimed he was. Perhaps it had even found that his mother's teaching method had been to go straight to tunes, to the neglect of scales and exercises.

Evidently Mrs Beardsley intervened by post in his tuition. He wrote to her: 'I thank you for the piece of music which I received this morning. I am learning *Fading Away* and then I shall begin the Sonata.' No doubt she had sent the sonata as a substitute for the 'rubbish' (which sounds like an exercise in diminuendo) provided by the school.

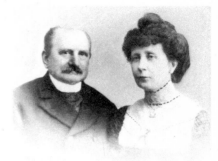

This photograph of Vincent and Ellen Beardsley together, evidently quite late in the marriage that Ellen represented as so unsatisfactory, was first published in Malcolm Easton's book *Aubrey and the Dying Lady*, 1972.

(*Opposite*) Aubrey Beardsley. At seven he wrote home from boarding school: 'When is my engine going to be mended?'

If Ellen Beardsley's memory later suppressed a friendship between herself and Miss Barnett, that was probably because it was Miss Barnett who taught Aubrey music. However, it was surely not Miss Barnett who tried to make Aubrey cry by beating him. Tears at their music lessons were more likely to be on her side, to judge from his cheerful account to Mabel: 'At first Miss Barnett was nearly bald with teaching me.'

The unnamed schoolmistress was not the only person Ellen Beardsley accused of beating Aubrey. The role of heroic martyr in which she cast herself was easily extended to her children. The role of chief villain fell to her husband. Beardsley scholars have uncritically accepted R. A. Walker's judgment on Vincent Beardsley: 'I can find nothing recorded to his credit. He was bad tempered, very jealous of his charming wife, and a cruel parent. He used to beat his two children when they were naughty and he never contributed regularly to the maintenance of his family.'

As a matter of fact, many people would have considered it strange, in the 1870s, if he had *not* beaten his children when they were naughty. Many fathers – and, indeed, many schoolmistresses – did then beat children, and considered themselves not cruel but kind for doing it.

However, that and all the accepted 'facts' about Vincent Beardsley deserve to be treated with scepticism, because, by the time Walker failed to find anything recorded to his credit, the record was in the sole hands of Ellen Beardsley. Walker's enquiries were presumably made about the time, 1920, of the interview with Ellen Beardsley that he wrote down verbatim. Vincent Beardsley, dead since 1909, could not amend or contradict. Mabel Beardsley had died in 1916.

To vindicate Vincent there remains only the often ambiguous testimony of a little boy's letters. The first of Aubrey's surviving letters, written, according to the editors of his letters, at Christmas 1878 (when he was six) and from Brighton (where he was perhaps spending Christmas with Pitt relations and where the family was, to judge from the text, reading a book about Captain Cook that had been a Christmas present from Vincent Beardsley), reads: 'My dear Dad, I wish you a happy Christmas. I have made you a marker; it is affection, because I love you. We enjoy Cook's travels very much. Your loving son, Aubrey.'

Perhaps (as one of his biographers assumes) he was seeking affection he did not receive. Or perhaps he meant exactly what he said. Perhaps he meant what he said but was too young to recognize that his father was a monster.

His letters from school, however, contain one unambiguous item of evidence of Vincent Beardsley's actual behaviour towards his son. In February 1880 Aubrey wrote from Hamilton Lodge to his mother: 'I had three valentines on Valentine's day. I think one was from

(*Opposite*) Ellen Beardsley

Papa.' It seems unlikely that a man who sent his seven-year-old son a valentine was 'a cruel parent'.

Whereas Ellen Beardsley led Walker to think that Vincent was jealous by temperament, it was in fact she whose response to Aubrey's letter from school was evidently a jealous protest that her own part in the shower of valentines had not been noticed. In his next letter, which was to Mabel, Aubrey wrote: 'Please tell Mother I did have four Valentines: I made a mistake.'

No one who looks with a psychological eye at Beardsley's drawings could doubt that his mother's was the major presence in his imaginative life. The drawings owe their erotic force to the fact that, thanks to her continuing in the central place in his mental world, he was able to keep intact the fierce, son-to-mother eroticism of childhood. His imagination exploited the 'polymorphous perversity' of childhood. His decoration is fetishist by virtue of a child's curiosity about the human sex organs. His line is fastidious because a child pays intense, erotically charged attention but may not touch.

To the erotic charge in their relationship Ellen Beardsley surely, though unconsciously, contributed. After Aubrey's birth she mentally paired herself not with her husband but with her son. Whether Vincent Beardsley vacated the father's place or was edged out of it by Ellen and her perhaps fantasized tales of his insufficiency, Ellen Beardsley tried to make herself solely responsible for Aubrey's support and cultural education, and she conducted with him an intense and exclusive relationship which she defended from interference even from other teachers of music.

From the intensity of the relationship Aubrey had a respite during his periods at boarding school (during the first of which he escaped from music, where his mother owned him, into drawing, in which he was eventually to express the ambivalence of his feelings towards her) and then during the brief period when he was adult, a professional artist and comparatively well. At that period Ellen Beardsley probably had to use Mabel as the instrument of her possessiveness over Aubrey. As her written account says, 'He cared very little for people, his only companion was his sister.'

It was with his sister that, in 1893, he set up house and entertained friends. Gossip, contemporary and posthumous, perhaps got the psychological if not the literal facts right when it suspected the siblings of incest. For Aubrey, Mabel was part escape-route from their mother and part doublet of her. In his letters he sometimes used the same name, though no doubt differently pronounced, for them both, addressing Mabel as 'Dearest Ma' and sending his love, via Mabel, to 'dear Ma'.

Ellen Beardsley, however, never surrendered her place to Mabel. In her spoken account to Walker she virtually dismissed Mabel from an

intimate part in Aubrey's life. And when she spoke of Aubrey's death at Menton (a town in the south of France which had been much swopped between Genoa, Monaco and France and which she and many others still thought of under the Italian version of its name), she disclosed the price of her own intense pairing with Aubrey. She could insist on the innocence of the relationship only by prettifying both herself and him into make-believe children.

Aubrey and I were one. He was the dearest boy, gentle, affectionate and whimsical. Mabel was more practical.

Aubrey was such a child always. People said his drawings were degenerate and vicious, but it wasn't true. He was clean-minded, and such a child. . . .

Aubrey and I never quite grew up. He always loved toys. You should have seen the collection we had at Mentone. I used to buy him some trifle whenever I went out. . . . He liked to think I had been thinking of him while I was out.

So often, in her own view of herself, martyred beyond the call of duty and the facts, Ellen Beardsley seems to have averted her mind's eye from her sufferings at Menton. Her account of Aubrey's death, in a letter giving a friend the news, is in terms of formal sentimentality. She was no doubt protecting herself from her own grief. But perhaps she was also afraid of discovering that she did not wholly hate his illness, since his illness delivered him back into the complete bodily and circumstantial dependence on her which she had tried to insist on when he was a child. The true sense in which 'Aubrey . . . never quite grew up' was that, in his terrible second childhood at the age of twenty-five, she repossessed him as a child and made him subject, inescapably, to that powerful relationship in which 'Aubrey and I were one'.

At Hamilton Lodge she could pursue him only by post and he could contrive not to see the valentine that came from her. But at Menton he could not escape the tokens of the relationship and could not avoid giving the responses imposed by her fantasy that they were a pair of children. 'He loved getting presents and a little parcel, even if it only contained a couple of chocolates, gave him so much pleasure.'

ELLEN BEARDSLEY'S DATING of events is impressionistic, but it seems that Aubrey had only a couple of years at Hamilton Lodge. When he was nine (which he became in August 1881) he was, by his mother's written account, 'taken to Epsom to get strong, and remained there for two years'. Perhaps Epsom, as a spa, was thought healthier than Hurstpierpoint.

I think the probability is that what Ellen Beardsley meant by his being taken to Epsom is that the whole family went to live there. The two years at Epsom, which from her indications must have been between 1881 and 1883, fall within Vincent Beardsley's employment

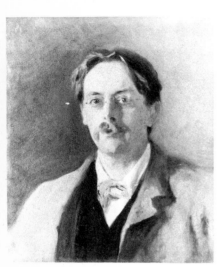

Edmund Gosse (1849–1928) by
J. S. Sargent. Writer, acquaintance
of writers (including Beardsley) and
promoter of English interest in
Scandinavian writers (especially
Ibsen), Gosse received a Norwegian
knighthood in 1901 and a British one
in 1925.

(*Opposite, above*) One of Beardsley's
childhood drawings in the manner of
Kate Greenaway.

(*Opposite, below*) At twenty-one
Beardsley transformed 'the little
Greenaway girl' into this 'grotesque'
(as he called the free-fantasy
decorations he provided for three
volumes of collected *bons mots*
published in 1893–4).

by the brewery at Vauxhall. However, Epsom is only fifteen miles and less than half-an-hour's train journey from London. Some of the trains from Epsom to London still stop at Vauxhall station. I imagine Vincent Beardsley went daily to work by one of the two railway lines that then served Epsom, the London, Brighton and South Coast line and the London and South Western.

At this period Aubrey made his first earnings from drawing. His mother's written account implies he was eleven; in her interview with Walker, she said he was nine. He was, as she remembered it, 'sitting up at the table with his coloured chalks and drawing things, when a friend came in and admired his little pictures very much.'

The patron was a Lady Henrietta Pelham. (She was born in 1813; her father was the second Earl of Chichester; and she lived in London, in Chester Square.) She commissioned Aubrey to provide decorated menus and guest cards for a wedding in her family, and from that and other commissions from her he earned about £30.

Fifteen of his drawings for Lady Henrietta survive. After her death in 1905, they were inherited by her nephew, who gave them to a fellow civil servant of his at the Board of Trade, Sir Edmund Gosse, the *littérateur* and autobiographer. Gosse had been a literary acquaintance of the adult Beardsley, who dedicated to him his edition of *The Rape of the Lock*. In 1928 Gosse set down the Pelham side of the story: Lady Henrietta was acting from kindness, because the Beardsley family was 'in destitute circumstances'; as well as commissioning pictures from him, she paid for Aubrey's music lessons.

Yet, since she preserved some of the drawings, perhaps she was exercising not only charity but talent-spotting. If so, she must be one of the most percipient patrons in history. In the two drawings exhibited at the Victoria and Albert Museum in 1966, it is hard to spot great talent or even a very remarkable precocity. Indeed, they were happily catalogued there as being done when Beardsley was eight, a year younger than in even the more extravagant of his mother's claims. They are copies of illustrations by the illustrator and author of children's books, Kate Greenaway. 'The only unoriginal work he ever did in his life' was Ellen Beardsley's written comment on the drawings he produced for his first commission. But in her spoken reminiscences she was less stern: 'Aubrey was very fond of drawing the little Greenaway boys and girls.'

The slightly sentimental taste, which was shared by John Ruskin, no doubt lasted longer in Ellen than in Aubrey Beardsley. Perhaps it was a pair of 'little Greenaway boys and girls' that her mind's eye saw when she asserted 'Aubrey and I never quite grew up'. Yet Aubrey's eye retained the image, and his hand a facility for recreating it, into his adult life. In 1892 he was commissioned to draw sixty 'grotesques' for three volumes, anthologies of *bons mots* by various English wits,

which J. M. Dent published in 1893 and 1894. Beardsley's drawings were free fantasies, unlinked to the text. It was a commission that liberated his invention but also, because of the sheer number of drawings required, taxed it. For one of his grotesques (for the middle volume, the point, perhaps, where invention sagged deepest), he had recourse to the image which he had grown practised in reproducing for the earliest commission of his life, and he turned in a scratchy, rather sinister rendering of 'the little Greenaway' girl.

As well as the pictures, Lady Henrietta preserved a letter written to her ('Dear Madam') by the boy Beardsley. He explains that his pictures are all copies from illustrations in books, his flower pictures being from a book sent him by Lady Henrietta – 'but they were failures as I was not very patient over them'; he shows himself willing to execute another commission, namely 'to make you anything for a bazaar'; and, with a power of self-criticism that speaks more for his talent than the drawings do themselves, he remarks: 'I often do little drawings from my own imagination but in doing figures the limbs are apt to be stiff and out of proportion and I can only get them right by copying.'

His letter to Lady Henrietta is dated 1 February, with no year; and the address at the top is 2 Ashley Villas. To this his editors append

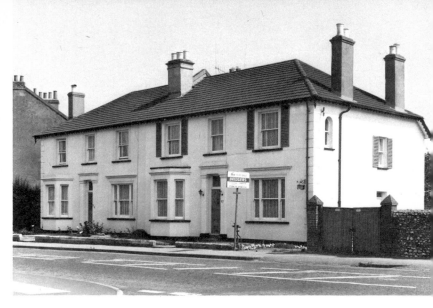

35 and 37 Ashley Road, Epsom. One of these houses, probably No. 37, can now be identified as Beardsley's home *circa* 1881–3. They were then named Ashley Villas.

'London'. However, there is and was at the time no such address in London. The clue to Beardsley's whereabouts when he wrote to Lady Henrietta is Epsom, where one of the main residential roads, running from the Downs up to the High Street (just beyond which is the railway station), is named Ashley Road. Nowadays it contains no Ashley Villas. However, the two houses under one roof that are now numbers 35 and 37 Ashley Road appear in the Valuation List of 1890 as Ashley Villas. And '2 Ashley Villas, Ashley Road' appears in the 1895 and 1899 editions of Andrews's *Epsom Directory* as the residence of a lodging-house keeper named Mrs Mary Ann Clarke.

One of these two houses (which are on the left of Ashley Road if you are going away from the High Street) can therefore now be identified for the first time as the address from which Beardsley wrote to Lady Henrietta Pelham and as where he lodged during (though not necessarily, of course, throughout) the Epsom episode of his boyhood. If the numbering of Ashley Villas, which ran only from 1 to 2, proceeded in the same direction as the present numbering of Ashley Road, then it was at the present 37 Ashley Road that he lived. In July 1975, 37 Ashley Road was for sale. The estate agent's description remarked that, with its ten rooms on three floors, it was suitable for use as a guest house and, as if to confirm my surmise that Vincent Beardsley travelled to work from there, emphasized that it is close to the station.

After the Epsom episode the Beardsleys returned to London, where Mabel and Aubrey 'entered', as their mother's account pretentiously puts it, 'into public and social life'. She meant, as the rest of her sentence shows, that they played duets and Mabel gave recitations at drawing-room entertainments. That they were not paid for performing she implied when she told Walker that Aubrey earned nothing

between the Pelham commission and his leaving school, but she may have wanted to emphasize her own part in their financial maintenance. Beardsley himself, in the rather wild notes on his life he wrote in 1894 for an article on him in *Hazell's Annual*, claimed: 'Took up music first as a profession and gave small concerts when I was about seven or eight.'

By his mother's reckoning, however, he was eleven when he left Epsom. His appearance in London 'public' life must have been brief, since he was still eleven when he made the move which, unforeseeably, was so vital to his art: the return to his birthplace, Brighton.

Unaccompanied by their parents, Mabel and Aubrey lived at Brighton with, as Ellen Beardsley variously put it, 'my aunt in Lower Rock Gardens' or 'a strange old Aunt'.

Lower Rock Gardens runs downhill to the front, to the east of and parallel with the Old Steine. The children's great-aunt owned number 21, which is on the right as you look uphill from the sea; and she has indeed become 'a strange old Aunt' in the hands of Beardsley scholars, who, in an exercise, perhaps, of creative scholarship, have communally invented a figment.

R. A. Walker scrupulously noted that, if she was a maternal aunt of Mrs Beardsley's, she would be a Miss Lambe and, if a paternal aunt, a Miss Pitt. (He seems to have taken it for granted she was unmarried.) Bothering to read only the first half of Walker's double condition, later biographers and editors have asserted unconditionally that the children lived in Brighton with their 'great-aunt Miss Lamb' and have even attributed to 'Miss Lamb' an earlier function in Aubrey's life, that of keeping an eye on his welfare while he was at school at Hurstpierpoint, as well as the later one of leaving him, at her death, £500.

However, the letter in which Beardsley referred to the legacy says that his 'old aunt' died 'about three weeks ago'. This approximate dating led me to her death certificate and thence to her will; and those documents have exploded 'Miss Lamb'.

The owner of 21 Lower Rock Gardens was, in fact, Sarah Pitt. She was one of the at least five sisters of the Surgeon-Major; and she died at her home, at the age of seventy-six, on 3 December 1891, as the result, in the magnificent phrase on the death certificate, of 'Decay of Nature'.

Sarah Pitt's house, 21 Lower Rock Gardens, Brighton. Mabel and Aubrey Beardsley lived with her here during their childhood. The road runs downhill to the sea-front.

Registration of the death of Beardsley's great-aunt, now identified as Sarah Pitt. She left Mabel and Aubrey Beardsley £500 apiece, which they inherited on reaching the age of twenty-one.

Columns:—	1	2	3	4	5	6	7	8	9
No.	When and Where died	Name and surname	Sex	Age	Occupation	Cause of death	Signature, description and residence of informant	When registered	Signature of registrar
257	Third December 1891 21 Lower Rock Gardens a.s.d	Sarah Pitt	Female	76 years	Landowner Daughter of Thomas Best Pitt M.D. (deceased)	Decay of Nature certified by H A Humphry F R C S	J Walker present at the death, 29 Montreal Road Brighton.	Seventh December 1891	S M Neate Registrar

To consign both her children to the care of 'a strange old Aunt' was a curious act for a parent as possessive and, in her own eyes, as conscientious as Ellen Beardsley. She implied to Walker that, at some time during their Brighton sojourn, she was unable to visit them because she was ill in a London nursing home. But she put forward no reason for packing them off in the first place. Like her account of her life with her husband, her account of the children's life with her aunt is open to scepticism, particularly since she may have been camouflaging what she suspected to be a dereliction of her duty.

She seems to have made a habit of blackening others in contexts that invited reproach to herself – which may be an unconscious confession that the black stories were fantasy defences against self-reproach. She so blackened Vincent Beardsley to R. A. Walker that Walker concluded there must have been in her 'a curious streak of perversity and obstinacy' for her to have married him at all. Equally, if the children's life with her aunt was as dreary as she said, Walker would have been entitled to ask why she ever allowed them to go there.

Her aunt had, she told Walker, 'peculiar notions about children', considered Mabel and Aubrey 'too precocious' and yet 'always pretended they were backward'. It sounds as if Sarah Pitt, like Miss Barnett before her, failed to see Aubrey as a musical prodigy.

By her niece's suspect account, Sarah Pitt allowed the children no toys (a slightly less unkind denial than Ellen Beardsley made it sound, given that the children were at least twelve and eleven), 'no books except Green's "Short History of England"' (by which she presumably meant John Richard Green's *Short History of the English People*, of 1874) and no amusements except church-going. The Surgeon-Major, Ellen Beardsley said, called one day at his sister's and protested against the joyless state of his grandchildren, 'sitting on their little high-backed chairs' with nothing to do.

It would be interesting to know if Sarah Pitt, allegedly so austere, really did provide them with small-size chairs (and indeed to know if they were still small enough to need them). But Ellen Beardsley's persistent use of 'little', which her son sometimes adopted, expresses her emotions rather than describes objects.

It is significant that Ellen Beardsley got the title of Green's *History* wrong. Green wrote a history of, pointedly, the people. Ellen Beardsley's High Tory sentiments were no doubt in conflict with the radical tone of the reading Sarah Pitt prescribed.

That she held progressive opinions (which may have been reason enough for her niece to call her 'strange') is confirmed by Sarah Pitt's will, which was made a couple of years before the Beardsley children went to live with her. .

The disposal of the estate is simple. It goes to a Miss Mildred Sarah Osborn after provision for legacies: £500 to Ellen Beardsley; £1,000

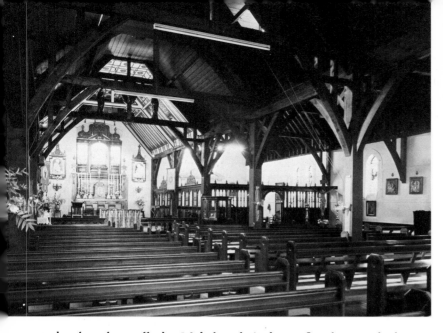

The inside of the church of the Annunciation of Our Lady, Washington Street. Although it is the far side of Brighton from Lower Rock Gardens, this was the church the Beardsley children frequented while living with Sarah Pitt.

to be shared equally by Mabel and Aubrey after they reach the age of twenty-one (they were in fact respectively twenty and nineteen when Sarah Pitt died); various amounts to her four sisters, three of whom were unmarried; £100 to her brother; small legacies, chiefly of nineteen guineas apiece, to several people, including Vincent Beardsley – which perhaps indicates that Sarah Pitt did not accept his wife's view of him as a monster.

Where Sarah Pitt's principles show is in her declaration 'that every benefit or interest taken by any female under my will shall be for her sole and separate use'. The year of the will, 1881, is the year in which the Married Women's Property Act became law. However, Sarah Pitt signed her will early in the year (on 19 January) and probably had it drafted earlier still, when she could not be sure that the Act would be passed. But she was in no doubt that it ought to be.

The church that afforded the two children 'their only interest', according to Ellen Beardsley, was, she recorded, 'a very high church, "The Annunciation", in Washington Street'. It is an eccentric building, terraced into a road of small and ordinary houses. Flinty fake gothic outside, it has an interior of plaster and exposed beams, with, presumably under the influence of the Aesthetic Movement, a couple of della Robbia-esque plaques flanking the altar. It still observes the quasi-Roman usages (mass and confession) of 'high' Anglicanism and still bears the un-Protestant name of the church 'of the Annunciation of Our Lady'. To reach it, the children must have undertaken a longish and chiefly uphill walk north from Lower Rock Gardens. Almost certainly they went of their own choice (a choice that later took them both from high Anglicanism into Roman

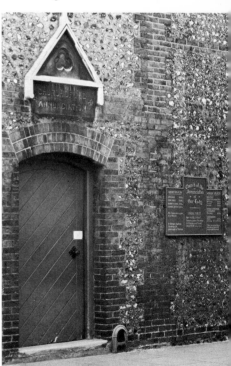

Beardsley's mother described the church of the Annunciation as 'very high', i.e. Anglican but practising the Catholic-type ceremonies still named on its present-day noticeboard.

Catholicism) and not, as one biographer states, at the insistence of their great-aunt. Indeed, the chances are that Sarah Pitt's religious tastes were opposite to theirs. Her will indicates an impatience of ceremony that may have been 'low church' – or that may have been simply common-sensical and thrifty. She wished to be buried, at a cost of not more than £30, in a common grave in whichever graveyard she happened to die nearest.

At twelve, Aubrey went, as a boarder, to Brighton Grammar School. (By Robert Ross's account, of 1909, he was a day boy for his first term and became a boarder only in his second.) To R. A. Walker Ellen Beardsley seems to have implied that school was a rescue from dreariness – though in that case it was odd of her not to bother to mention whether Mabel was rescued too. Walker's only information about Mabel's schooling was that she was converted to Catholicism 'as a school girl'. (By other accounts she was received in 1896 when she was twenty-four.)

Walker clearly adopted a hint from Ellen Beardsley when he wrote that Aubrey's fees at Brighton Grammar School were 'probably' paid by Ellen's father. Against this, which has sometimes been represented as a certainty, there is an inherent obstacle. At least by the time he died, the Surgeon-Major had virtually no money. He died at 18 Montague Place, Bloomsbury, London, on 27 October 1887, survived by his widow (to whom, in a codicil added just before her own death, Sarah Pitt transferred the £100 intended for him); and the gross value of his estate was £147 19s 10d.

Sarah Pitt, by contrast, whose death certificate describes her as 'Fundowner', owned not only the freehold of 21 Lower Rock Gardens but £3,300-worth of New River Company debenture stock at 4%. Evidently she took care to be expertly advised: the executors of her will came from, respectively, Canon Street and Mincing Lane. She seems a much more convincing candidate than her brother for the role of the benefactor who paid Aubrey's grammar school fees.

I had just framed this hypothesis when it was confirmed: by a letter from the present headmaster of the school. The application form for Beardsley's admission gives 21 Lower Rock Gardens as his 'temporary residence' and the 'name of Payor' as Miss Sarah Pitt of the same address.

Beardsley mentioned Sarah Pitt's death in a postscript to a letter he wrote, at nineteen, to the man who had been his housemaster at the grammar school. With real or affected toughness he remarked that she 'only left me £500'; and, expecting his correspondent to remember what he was referring to, he described her as 'the old aunt I used to pay so many visits to when at school'.

Those 'many visits' from school argue that the life he led with her before he went to the school was not repulsively dreary. And it is a

crucial instance of the distortions Ellen Beardsley imposed on events and people that she chose to record the alleged dreariness but to suppress the fact that Sarah Pitt paid for her son's schooling.

IF BEARDSLEY HAD TAKEN his chief aesthetic education from Brighton itself, it was his school that put it in his way to become one of the most literate, versatile and intellectually effervescent of artists.

Brighton Grammar School did not move to its present site, high up along Dyke Road, until 1913. During the years (1884–8) of Beardsley's pupilage, it was situated in the road where he was born: at what is now 80 Buckingham Road (to which it had moved, from 47 Grand Parade, in 1868). The school boarding house was next door.

Number 80 is now a maternity hospital and bears a plaque commemorating E. J. Marshall, whose headmastership of the school, running from 1861 to 1899, encompassed Beardsley's years there. Beardsley, who, as a fellow pupil later recorded, once stuffed the tails of Marshall's academic gown, while its wearer's back was turned, into an inkwell, won something of a clown's licence from his headmaster.

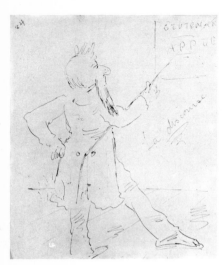

La Discourse, one of the caricatures Beardsley drew, during his school days, of his headmaster. They were collected by his science master and friend, A. W. King.

He developed a fluent caricature image of Marshall, in which Marshall's hair stands up in devilish horns. Yet he never felt sure of Marshall's approval. After he left school, he secured Marshall's promise of help with a career, but when, hoping perhaps to take up the promise, he sent Marshall an account of his artistic development, he felt obliged to add ritual pieties ('The finest inspiration for a young man is the remembrance of a pure childhood and a good school time') and (perhaps for fear Marshall would not otherwise swallow his pieties) an assurance that the 'privilege' of being Marshall's pupil, if 'not fully understood *then*', was 'keenly appreciated *now*'.

Beardsley's violet-ink caricatures of Marshall at school were collected and kept not by their subject but by A. W. (Arthur William) King, the school's science master and Beardsley's housemaster. It was King who inspired Beardsley's intellectual adventures, gave him the run of his library, afforded him, both during and after his school days, concrete help, and pursued with him a relaxed and affectionate relationship. 'If I ever succeed,' Beardsley wrote to him, 'I feel that it is very very much owing to you.'

At school, his mother recorded, Beardsley 'never did much work, but translated Virgil into English heroics'. Such a translation of the whole of Virgil would surely count as a great deal of work. At least, John Dryden found it so, when he prepared *his* Virgil in English heroic couplets, which he published in 1697. Perhaps Beardsley, who discovered the English seventeenth-century dramatists while he was at school, chanced on Dryden's translation and passed some of it off on his mother as his own.

His recorded schoolboy view of Virgil was unheroic: thirty satirical illustrations to Book II of the *Aeneid*. One set, which was collected by his classics master, H. A. Payne, has a general title in worse-than-dog Latin, in which Beardsley spells Virgil with a W (thereby disclosing which convention of Latin pronunciation Payne taught) and, coining and misusing a fake Latin adjective from the seventeenth- and eighteenth-century spelling of Brighton as Brighthelmstone, calls himself 'Beardslius de Brightelmstoniensis'. The last drawing illustrates an episode added to Virgil's text by Beardsley in a pair of bumpy doggerel stanzas, where Aeneas ties 'a balloon to his topper' and, instead of coming 'down a great flopper', goes 'for a turn To the moon with Jules Verne'.

Beardsley developed at school a facility, which he kept but never polished, for versifying. He was still only twelve when the school magazine, *Past and Present*, included in its issue of June 1885 his first publication: nine quatrains about the victory of the *Valiant* ('The *Valiant* was a noble bark') over a pirate ship.

One piece of his schoolboy doggerel was pointedly not for publication. 'Don't show this, I beg you, to dear Betsy Topp' is the last of its

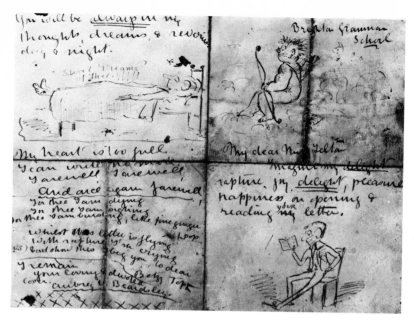

Part of a mock love letter that Beardsley, as a schoolboy, wrote to a schoolgirl.

Beardsley at fourteen, as 'Schoolboy' in the Christmas entertainment, drawn by a teacher, F. J. Stride, for the school magazine. The sailor above represents the approaching new year.

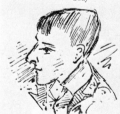

six lines (rhymed to 'For thee I am bursting, like fine ginger pop'). It is part of the second of two mock-impassioned love letters which, in response to an approach from her, Beardsley smuggled ('I will give the letter to Bessie Ashdown tomorrow at half-past five') to a schoolgirl in Betsy Topp's charge, a Miss Felton or, as the second letter apostrophizes her, 'My own Love'. Miss Felton must have either thought the letters funny enough or felt seriously enough towards their sender to have kept them.

Two years after his first literary publication, the school magazine (in the June 1887 number) published the first reproduction of Beardsley's graphic work: a sheet of eleven tiny sketches, illustrating cricketing puns, called 'The Jubilee Cricket Analysis'. The jubilee thus celebrated was the fiftieth anniversary of Queen Victoria's accession. In December of the jubilee year, the school's Christmas entertainment (which was regularly, to the benefit of Beardsley's eye, held in the Dome) was an historical pageant written by the house-master A. W. King. There were parts for Beardsley (who at the previous year's entertainment had in the persona of 'Schoolboy' delivered a prologue, also by King) and for his fellow pupils C. B. Cochran (who became a famous impresario in the twenties) and George Frederick Scotson-Clark, the closest of Beardsley's school friends and the one who most nearly shared his multiplicity of artistic interests.

King seems, indeed, to have turned Brighton Grammar School virtually into a school of drama. Beardsley was removed from it at the end of the summer term of 1888 and put to work as a clerk in London,

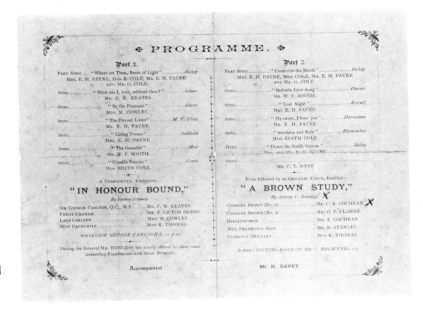

After Beardsley had left school, a farce by him, *A Brown Study*, was performed at an old boys' conversazione in the Royal Pavilion on 7 November 1890.

A programme of 'The Cambridge Theatre of Varieties'. ('Masher, *slang*, 1882. A fop of affected manners and "loud" style of dress who frequented music-halls, etc. and posed as a lady-killer' – *Oxford English Dictionary*.)

but the move scarcely interrupted his passionate theatricalism. In December he was back at the Dome, taking part, though he was no longer a pupil, in another of the school's Christmas entertainments, a production of a comic opera called *The Pay of the Pied Piper*. Beardsley, in addition to delivering, again, a prologue by King, played a role (Herr Kirschwasser) and designed the costumes. He also provided eleven illustrative drawings for the programme, where a prefatory note apologized for the failure, through lack of 'experience in the preparation of drawings for the photo-engraver', to do them justice in reproduction and described them as 'the perfectly original' work of 'a boy now in the school, A. V. Beardsley'. As Beardsley was no longer 'a boy now in the school', it is reasonable to guess that his removal was precipitate and against the school's advice.

As late as November 1890 Beardsley was still theatricalizing at Brighton, this time in the Pavilion itself and this time as an admitted former, not present pupil. The entertainment at a conversazione for the school's Old Boys Association included a farce, *A Brown Study*, which was produced and acted in by Cochran and written by Beardsley (whose name was misspelt on the programme).

In London Beardsley was pursuing theatrical expression privately and in alliance with his sister. At what they called 'The Cambridge Theatre of Varieties' ('*Costumier* Madame Mâbéllè, *Perruquier* M. Aubré'), they acted and sang 'The Jolly Mashers, A Charade in 4 Acts', whose principal characters were Masher No. 1 (A. V. Beardsley) and Masher No. 2 (M. Beardsley).

Perhaps for Mabel her role as a masher was a rehearsal for sitting to Graham Robertson in 1911 for her portrait in men's clothes and, to judge from the inscription, under the name 'Philip Beardsley'. Perhaps for Aubrey his sister in drag was the originating image that became his illustrations of female transvestite foppery: his picture, published in *The Savoy* in 1896, of William Wycherley's Mrs Pinchwife (Wycherley being one of the seventeenth-century dramatists Beardsley had read at school) and his picture (published in 1898 in a series of illustrations to Théophile Gautier's novel of 1835) of Mademoiselle de Maupin.

For both Beardsleys amateur theatre was an apprenticeship – and for Mabel a direct one. After passing 'the Higher Women's examination' with 'the highest honours in all subjects' (as Aubrey wrote to his former headmaster, no doubt putting forward Mabel's academic success, in the absence of any of his own, as a hook to catch Marshall's approval) and after teaching at the Polytechnic High School, she became a professional actress. ('I do not think', her mother told R. A. Walker, 'she would ever have made a really great actress. . . . Aubrey

(*Below, left*) Portrait, 1911, by W. Graham Robertson, inscribed to Philip Beardsley. No Philip Beardsley is known, and the portrait appears to be of Mabel Beardsley.

(*Below*) Beardsley's picture of the bisexual, transvestite heroine of Gautier's *Mademoiselle de Maupin*.

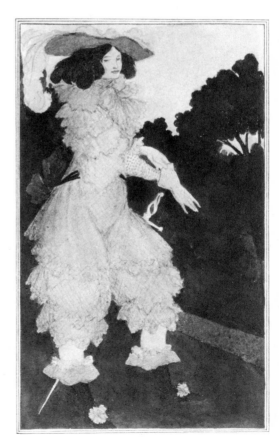

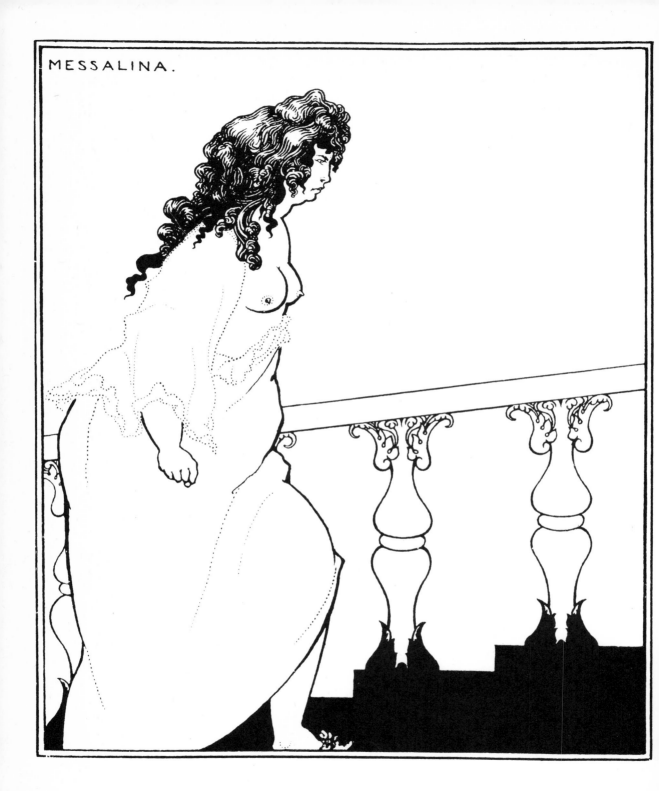

MESSALINA.

used to encourage her, but I used to tell her the truth about herself. She would cry and did not like it. But I had to tell her.')

For Aubrey, portrayer of singers and actors, illustrator of Richard Wagner's operas and audience, the theatre provided much immediate material. At the same time, an imaginary theatre became one of the regular settings for the persons and events of his imagining. The cast of 'The Cambridge Theatre of Varieties' was by 1894 transmuted into 'The Troupe of the Theatre-Impossible', whose mysterious 'Comedy Ballet of Marionettes', the courtship of two women to an accompaniment of dwarfs, Beardsley drew in three staged scenes and published in *The Yellow Book*.

From mime he borrowed the character of Pierrot – sometimes to illustrate the work of writers like John Davidson and Ernest Dowson who had borrowed him too. Indeed, Pierrot's enigmatic sadness and isolation became so fashionable that in 1896 John Lane issued a series of novels, the first of which was called *Pierrot*, under the collective title of Pierrot's Library, all with uniform title pages, covers and end-papers by Beardsley.

Beardsley might have written of his own what he wrote of Volpone's 'passion for the theatre': 'Disguise, costume and the attitude have an irresistible attraction for him, the blood of the mime is in his veins.'

Beardsley's was essentially a theatre of mime, because it was a silent theatre, visible but not audible on the page. His own identification with Pierrot was explicit in his unrealized project, of 1893, for a series of pictures and poems called *Masques*, for which 'I want', he wrote, 'a prologue to be spoken by Pierrot (myself)'. And it was his own death he foretold in his drawing, in *The Savoy* of October 1896, *The Death of Pierrot*. The troupe of masked *commedia dell'arte* personages tiptoes in a line towards Pierrot's deathbed, miming the message of silence with fingers to lips. You can tell they are on a stage because they are looking not towards their destination but towards an audience.

The Beardsley siblings named 'The Cambridge Theatre of Varieties' from the family's address: 32 Cambridge Street, in Pimlico. This, as the Post Office Directory shows, was, in 1890, when the Beardsleys were living there, a lodging house, kept by a Thomas Gardner. In 1891 the Beardsleys moved, but only as far as an intersecting street and to another lodging house, 59 Charlwood Street, where the landlady was a Mrs Elizabeth Ford.

It crosses my mind that for one of his greatest pictures, the *Messalina Returning from the Bath* which was first published in 1899 and which was intended to illustrate Juvenal's sixth *Satire*, Beardsley may have conjured his image of the terrifyingly selfish, cruel and powerful empress of Rome from his large and no doubt terrorized early experience of landladies, who so regularly exert their power over their lodgers about precisely such matters as returning from the bath.

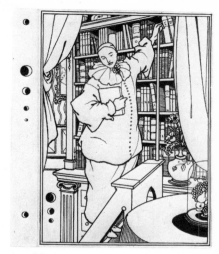

Beardsley's design was stamped in black on the spine and front of volumes in the Pierrot's Library series.

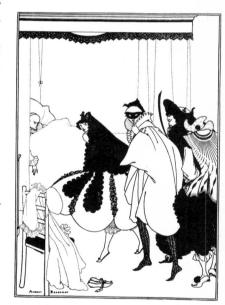

Beardsley's *The Death of Pierrot*. It was published in *The Savoy* No. 6, October 1896.

(*Opposite*) *Messalina Returning from the Bath*. Published posthumously, this is one of Beardsley's illustrations to the first-century satirist of the Roman empire, Juvenal.

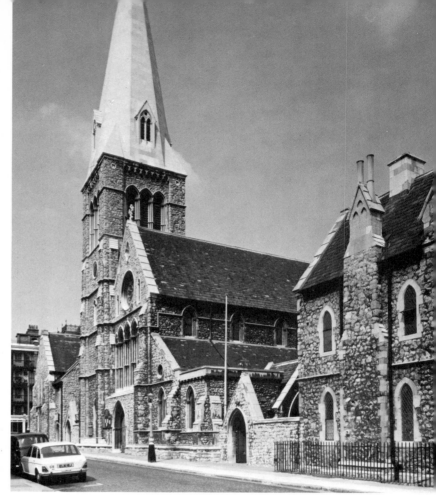

The Beardsleys' fidelity to Pimlico (in 1893 Beardsley adapted his schoolboy Latin joke of Brightelmstoniensis and signed himself, in a letter to Robert Ross, 'Aubrey B. Pimliconiensis') owed something, I surmise, to the fact that Beardsley's childhood patron, Lady Henrietta Pelham, lived in the northern part of the district (which might be called Belgravia but was then officially designated Pimlico). It no doubt owed more still to the clergy of St Barnabas's church, Pimlico. At 32 Cambridge Street the Beardsleys were directly opposite an Anglican church, St Gabriel's. But Aubrey at least must have ignored that in favour of St Barnabas's, which was more distant but 'high' – and where not only the vicar, the Rev. Alfred Gurney, but also the curate's brother became early patrons of his work. Ellen Beardsley had met Gurney when he was a curate at St Paul's, Brighton (another 'high' church), and in Pimlico Gurney made it his habit to commission his Christmas cards, on pious subjects, from Beardsley.

When he left school in 1888 Beardsley was a month short of sixteen. His first and temporary job was as a clerk in the District Surveyor's office of Clerkenwell and Islington. (The neighbourhood suggests to me that Vincent Beardsley, though scarcely able, by his wife's account, to get himself a job, exercised some local or family influence on behalf of his son.) On New Year's Day 1889, he began his clerkship, for which he had to have a nomination (secured, I surmise, from one of Sarah Pitt's City acquaintants), at the Lombard Street office of the Guardian Life and Fire Insurance. His hours were 9.30 to 5.30; his work, he told King, was not hard; but, although he didn't 'exactly dislike' it, he was 'not (as yet) frantically attached'.

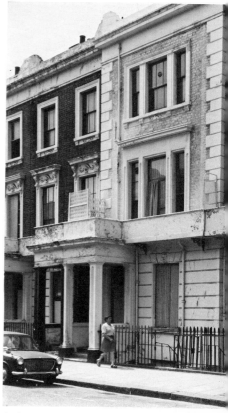

(*Above*) 59 Charlwood Street, Pimlico, the Beardsley family's next lodging (kept by Mrs Ford). The house has obviously been extensively repaired, probably after bombing in the 1939–45 war.

(*Opposite, above left*) 32 Cambridge Street, the Pimlico lodging house (kept by Thomas Gardner) after which the Beardsley siblings named their 'Cambridge Theatre of Varieties'.

(*Opposite, right*) St Barnabas's, the 'high' church Beardsley frequented in Pimlico. The vicar, Alfred Gurney, was an early buyer of his work.

(*Opposite, below*) *Adoramus Te*, one of the early (and pious) Beardsleys owned by the vicar of St Barnabas's, Pimlico. Beardsley designed it for him as a Christmas card.

AFTER ELEVEN MONTHS of insurance clerkship Beardsley thought he had lost his job. (As it proved, he was able to resume it.) He kept the Christmas of 1889 'on slops and over basins'. The specialist he consulted attributed (presumably wrongly) his haemorrhages to the state of his heart rather than of his lungs but, even so, wondered how he had kept going.

Whether at the intimation of early death or through the acceleration of the disease itself, Beardsley's intellect accelerated. He proudly chose to send word of his illness to A.W. King (who had meanwhile moved from Brighton to Blackburn Technical Institute) on the day, 4 January 1890, that his professional career began – which it did with writing, not drawing. The magazine *Tit-bits* published a piece called *The Story of a Confession Album*, the first work Beardsley had tried to sell, and paid him £1 10s.

Even in the leisure forced on him by illness Beardsley read, he reported to King, all the time – and could 'read French now almost as easily as English'. (This concentrated reading seems a likelier source of his 'uncanny knowledge of French' than his mother or his supposedly French nursemaid.)

His letters of 1890 and 1891, chiefly to King and Scotson-Clark ('My dear Mr King' to his former teacher, 'My dear Clark' to his former fellow pupil), are a record of intense, self-educative experience: books read (his personal scrapbook, dated '6/5/90' on its flyleaf and filled with illustrations, bore witness to his exploration of French literature); plays attended (he drew a scene from Henrik Ibsen's *Ghosts*, which, in its first English production, was under attack in the press as 'an open drain' and 'a loathsome sore unbandaged' which only 'nasty-minded people' went to see); and exhibitions, collections and galleries visited.

He visited the house in Prince's Gate where J. A. M. Whistler had, in 1877, decorated the Peacock Room for the shipowner Francis Leyland. Beardsley admired Leyland's Pre-Raphaelites and Old

Masters as well as his Whistlers; and in Whistler he admired not only his skill as a painter but his wit as a public controversialist. At Hampton Court, which housed the *Triumph of Caesar* cartoons, he fell in love with Mantegna. (The love lasted. Beardsley borrowed a motif from a Mantegna composition for an early drawing, repeated it in a later one, drew an imaginary portrait of Mantegna and died with reproductions of Mantegna's work in his hotel room.) In August 1891 he 'turned into the National Gallery' and saw its 'new acquisition' (acquired in 1890), the younger Hans Holbein's *The Ambassadors*, judged it 'a damned ugly picture' and a month or so later confessed himself 'ashamed' of the judgement.

Ellen Beardsley's account, 'many an hour did he and his sister spend in the National Gallery, fixing their attention only on the Pre-Raphaelite pictures', was footnoted by Walker with the remark that it would have been difficult to see many Pre-Raphaelite paintings there at the time. But in this instance Ellen Beardsley was right. She meant, literally, painters who lived before Raphael, and not the followers of the nineteenth-century English 'Brotherhood' that tried to recapture their supposed innocence. Beardsley's 'first enthusiasm', Robert Ross recorded, 'was for the Italian primitives'. (Mantegna, though far from primitive, perhaps counted as pre-Raphael, since he died fourteen years before Raphael did.)

It was, however, a Pre-Raphaelite of the latterday and living kind whose generosity gave Beardsley's career its decisive impetus. Edward Burne-Jones was a Pre-Raphaelite in the extended, not the strict, sense. He had not been one of the original Brotherhood. But he had been a director of 'the firm', the multi-media do-it-yourself company which was founded in 1861 as something of a Pre-Raphaelite cooperative. Though the firm presently became William Morris's exclusive property, Morris and Burne-Jones remained close friends and frequent collaborators. In 1877 seven of Burne-Jones's pictures were exhibited at the Grosvenor Gallery (which later became the Aeolian Hall) in New Bond Street. They included one with an Arthurian theme. The stories of King Arthur and Queen Guinevere were Burne-Jones's favourite subject matter: in 1895 he did the designs for a staged version, which Bernard Shaw reviewed, dispraising the text but praising Burne-Jones. Burne-Jones was among the targets, in 1881, of Gilbert and Sullivan's anti-Aesthetic satire in *Patience* ('greenery-yallery, Grosvenor Gallery') but that was a sign that he was already fashionable and about to become venerable. Indeed, by 1891 he was only three years short of his baronetcy.

On Sunday afternoon, 12 July 1891, Mabel and Aubrey Beardsley (on the spur of the moment, Beardsley afterwards claimed, though he had told Clark of his intention a week beforehand) went to Burne-Jones's studio, which they had heard was open to the public. Burne-

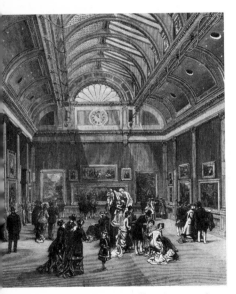

The Grosvenor Gallery in 1877, its opening year. Though the pictures were hung on red, it was the green velvet beneath them, plus the gilt above, that provoked W. S. Gilbert's 'greenery-yallery'.

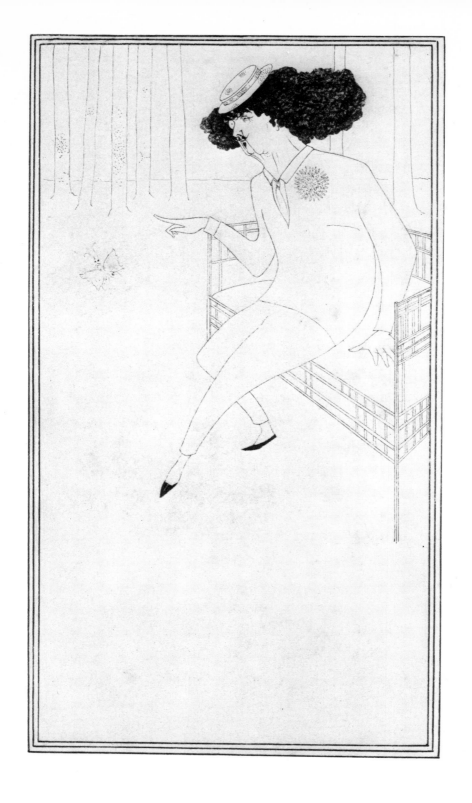

Photograph of Oscar Wilde taken by Downey about the time (1891) the Beardsleys met him and his wife, Constance, at Burne-Jones's house.

Burne-Jones's London house, The Grange. Now demolished, it was at the north end of the North End Road. Here the Beardsley siblings met Burne-Jones in 1891.

Jones's London home, The Grange, an eighteenth-century house, was in West Kensington, at 49 North End Road (in the part of the road near what is now Olympia; the house was demolished about 1957 and the flats now on the site bear Burne-Jones's name).

The Beardsleys were told the studio was no longer open without an appointment. They turned to leave and were overtaken by Burne-Jones himself, who insisted on showing them his pictures and then on looking at Beardsley's. ('By the merest chance,' Beardsley shamelessly told King, 'I happened to have some of my best drawings with me.') To Aubrey, Burne-Jones gave praise and the advice, which he emphasized he was not in the habit of giving, 'to take up art as a profession'; and to both Beardsleys he gave tea on his lawn in the

company of his guests, who included Oscar and Constance Wilde. Beardsley's account to King ended: 'We came home with the Oscar Wildes – charming people.'

Burne-Jones followed up his kindness with a four-page letter of more specific advice. Taking it, Beardsley, who was still clerking by day, began to attend evening classes at the Westminster School of Art, under Fred Brown, a founder of the New English Art Club, of whom Beardsley wrote to King that he 'is tremendously clever with the brush, and exhibits A.1 work at the Academy'.

Burne-Jones, in advising Beardsley 'You must learn the grammar of your art', took it for granted that his art would be painting. At their first meeting he prophesied: 'One day you will assuredly paint very great and beautiful pictures.'

In the event, though Beardsley occasionally used watercolour in conjunction with pen and ink and though he designed his posters to be printed in colour, of the sort of pictures Burne-Jones had in mind, namely oil paintings, he produced only two: back to back on the same canvas, left disregarded behind in a house he had vacated, there

Beardsley's picture of Fred Brown, a founder member of the New English Art Club (whence the 'N.E.A.C.' in the picture) and briefly Beardsley's teacher at the Westminster School of Art.

This astounding anticipation of both surrealism and psychoanalysis is one of Beardsley's two known oil paintings. He left it behind when, in 1895, he moved out of 114 Cambridge Street.

found by the next tenant and eventually sold – to, in turn, R. A. Walker and the Tate Gallery. One of the paintings shows a woman in black and a black page in scarlet in a palatial setting. In the other, a masked woman, wearing black, sits at a table on which there is a white mouse.

Burne-Jones assumed not only that Beardsley would paint but that his drawings were sketches for paintings. After going through Beardsley's portfolio he remarked (ungrammatically if Beardsley's report was accurate): 'Every one of the drawings you have shown me would make beautiful paintings.'

Burne-Jones had, in fact, recognized the existence but not the nature of Beardsley's genius. The misunderstanding was helpful in that it set Beardsley to explore his genius himself. His intellectual

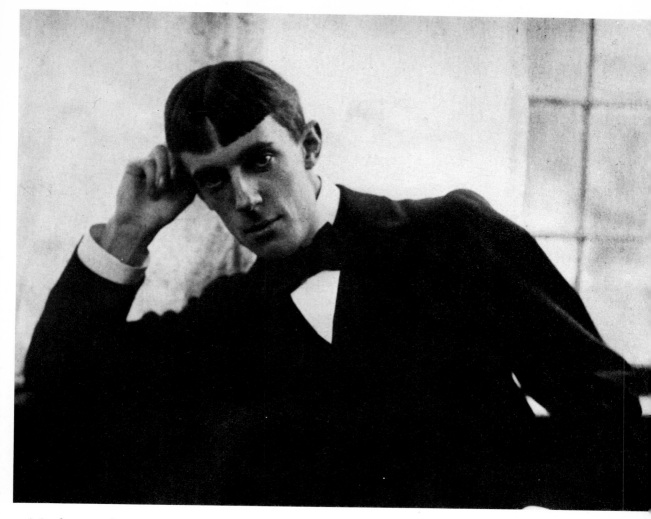

activity began taking directions that served, inexplicitly, to define himself for himself.

The act of definition (which proceeds in part by differentiating him from painters) is visible in a letter he wrote King on Christmas Day 1891. King had by then taken charge of Blackburn Technical Institute's magazine and Beardsley had already contributed a drawing to it. Beardsley now hinted he would like to be asked for an article (though when King did ask him he withdrew, because he had found an article making much the same point by the illustrator and socialist Walter Crane): 'I am anxious to say something somewhere, on the subject of *lines* and line drawing. How little the importance of outline is understood even by some of the best *painters*.' And he added in the next paragraph: 'Could you reproduce a drawing purely in line?'

Photograph of Beardsley by Frederick Hollyer. Beardsley gave an inscribed print to William Rothenstein. To Max Beerbohm he gave an inscribed print painted over in watercolour to make a self-caricature.

49

To Beardsley it came almost as a single thought to propose an article that should state and a drawing that should incarnate 'the importance of outline'. His prime act of self-definition must have been to recognize that both his talents, for literature and for drawing, were literary. Having begun his professional career with a piece of journalism, he continued all his life to practise, sometimes brilliantly, as a professional writer. Meanwhile, his drawing was indivorceable from literature. Most of his pictures have literary subjects or sources. Several incline towards merging into written art, because he has lettered their titles on them. He sought commissions as an illustrator; and before there was any hope of commissions his private scrapbook showed him to be an illustrator by choice and by the natural turn of his imagination. When his graphic talent was set free from a text, as it was in his commission for the *Bon-Mots* series, he produced what were in effect illustrations of the literary content of his own imagination. The imaginative impulse that created the bizarre and macabre *Bon-Mots* grotesques presently created the bizarre characters of his novel. *The Story of Venus and Tannhäuser* and the macabre story of his poem *The Ballad of a Barber*. And then, so indivisible were his talents, he created some of his finest pictures as illustrations to his own novel and his own poem.

Perhaps it was because they were the colours of print, and thus of literature, that he was able to commit his graphic genius, almost exclusively, to black and white. Instead of being restricted by the absence of the other colours, he was able to treat black and white as a means of expressing or implying them. That act of artistic magic perhaps came naturally to his genius because it was analogous to the magic whereby literature expresses appearances of all kinds in words.

While he was exploring both the galleries of London and the nature of his own talent, Beardsley became aware of his power to imply colour. He often sent Clark sketches of pictures that had excited him. Sending him, in 1891, his 'impression' of a Whistler seen in an exhibition (and now to be seen at the Tate), Beardsley wrote in his accompanying letter: 'My impression almost amounts to an exact reproduction in black and white of Whistler's *Study in Grey and Green*.' It was his own first glimpse of the Beardsley magic. To his mature magic Robert Ross paid (in 1909) the compliment that one did not need to consult the text of Wilde's *Salome* but could tell from Beardsley's black and white pictures that Herodias's hair was purple.

Once he had recognized 'the importance of outline' and his own power to imply colour, Beardsley was in a position to recognize that he could create drawings which were completed pictures in themselves. 'Picture' became one of the terms he regularly applied to his drawings. He applied it in 1893 when he told Clark that his 'large picture of *Siegfried*' had been given 'a place of honour' in Burne-

Jones's drawing-room. Perhaps Burne-Jones was acknowledging that Beardsley's drawings did not, after all, need transcribing into paint.

Beardsley's self-exploration was summed up in the epigrammatic and condensed essay, *The Art of the Hoarding*, that he published in 1894. With an analytic power as well as a verbal *bravura* to challenge Wilde, he attacked 'the popular idea of a picture' as 'something told in oil or writ in water' and meant to be hung in a gallery ('Our modern painter has merely to give a picture a good name and hang it'). He proposed that a poster might be a picture, that hoardings were not worse places than private galleries for the display of art, and that the hoarding had the advantage of charging no admission fee; and he wittily dismissed as snobbery the 'general feeling that the artist who

Photograph of Burne-Jones's drawing-room (with small copies of Michelangelo's *Morning* and *Night* on the mantelshelf) at The Grange. It was presumably here that Beardsley's *Siegfried* hung in 'a place of honour'.

puts his art into the poster is *déclassé* – on the streets – and consequently of light character'.

Except in its opposition to snobbery, it was not the creed of a Pre-Raphaelite. Beardsley's recognition of his divergence from Pre-Raphaelitism was delayed by his affection for Burne-Jones and, probably, by the accident that his talent was literary: he must have persuaded himself for a year or two that he was conforming to Pre-Raphaelite tradition since he took literary subjects for his pictures (as Burne-Jones did) and was both visual artist and writer (as Morris was and D. G. Rossetti had been). As late as 1893, in the same letter which recorded Burne-Jones's hanging of the *Siegfried*, Beardsley assured Clark: 'I still cling to the best principles of the P.R.B.' (the Pre-Raphaelite Brotherhood). But that was a tacit confession that he had to cling and that not all the Brotherhood's principles now seemed to him 'the best'.

Although it was reproduced in a magazine, Beardsley's *Siegfried* (which illustrates Act II of Wagner's opera) was not intended for reproduction. It made an apt present to Burne-Jones. It is the point of transition between the Beardsley of Burne-Jones's expectations and the Beardsley of Beardsley's own creating. As if in token of the transition, it is signed twice: with the initials A. V. B. and with the device which Beardsley had just invented and which he called his 'trade mark'. A line penetrating between two lines and dissolving into drops, it is a diagram of sexual penetration and ejaculation.

The poetically apt double signature on the *Siegfried* came about, I imagine, by accident and perhaps a touch of embarrassed *contretemps*. No doubt Beardsley presented the picture signed only with his new trade mark, which Burne-Jones failed to recognize as a signature, and Beardsley added the initials when Burne-Jones asked him to sign his gift.

From the *Siegfried* on, virtually all Beardsley's major drawings were intended and indeed actively designed to be reproduced. Having committed his graphic talent to the colours of print, he went on to the extreme and artistically economic course of committing it to print itself. It was the point of his break both with the conventions and with the 'principles of the P.R.B.'

By the conventions, easel painting was not *a*, but *the* supreme form; an easel picture was produced and, ideally, seen by natural light; and a good part of an artist's expertise went into the pursuit of natural light either out into the landscape or in an expertly chosen studio. Beardsley worked always indoors, in ordinary domestic rooms and very often by night. His pictures were often created by artificial light, shed perhaps from the two talismanic candlesticks he possessed (and incorporated in various disguises in several of his designs); and they were intended to be seen by whatever light people in industrialized

(*Opposite*) Beardsley's Wagnerian picture *Siegfried, Act II*, which he gave to Burne-Jones. It is signed on the left with Beardsley's emblematic 'trade mark' and on the right with his initials.

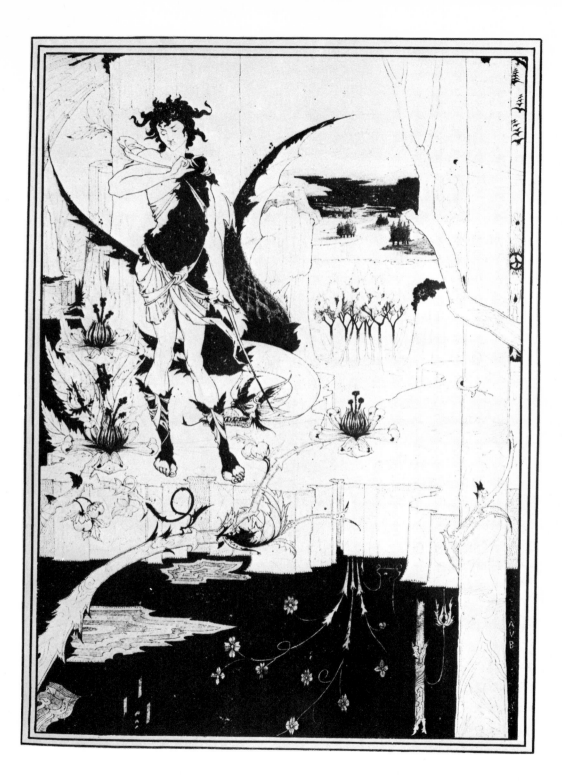

societies read books and magazines or glimpse posters on hoardings. The poster, his essay pointed out, was a form of art that could 'take a part in everyday existence'. Nothing was lost if you looked at Beardsley's pictures in 'everyday' circumstances, because in printed work, as his essay put it, there was 'no brush work' for critics 'to prate of' and beauty was achieved 'without modelling'.

He was himself 'the artist who puts his art into the poster' (and the page). What it went into was the design, the whole of which could be conveyed in reproduction. ('Design' was another word Beardsley regularly applied to his own drawings.) And – which shocked snobs – the art he put into it was not the mere knack of the commercial artist but original genius wearing the entire and learned panoply of western (plus a touch of Japanese) culture.

His offence to Pre-Raphaelite principles was subtler; the principles themselves were better intentioned. Beardsley's essay begins, with a purely Wildean cadence: 'Advertisement is an absolute necessity of modern life.' Pre-Raphaelitism was largely an objection to 'modern life', on the social grounds that the production of identical objects by modern industrialized process killed the soul and the individuality of both the producer and the consumer. In its attempt to replace industrialism by a regeneration of craftsmanship, Pre-Raphaelite thought came near to crediting hand-crafted objects with another social value, this time a capitalist one, namely the rarity value of a unique object. Beardsley's perception was that neither argument was an aesthetic argument. He accepted, as the Pre-Raphaelites couldn't, the aesthetic neutrality of technology. The artistic virtue of the poster was unaffected by the number of replicas but depended wholly on the quality of the design.

That Beardsley was unfrightened by technology, and thus by 'modern' and 'everyday' existence, he may have owed, I think, to the simple chance that his early (and highly literate) mentor, A. W. King, was a teacher of science.

It was into 'modern life' that Beardsley advanced when he left Pre-Raphaelitism. He made, I think, his formal adieux when (which was probably in 1892 or 1893) he chose to draw, in a manner not at all Pre-Raphaelite but wholly Beardsley, a sympathetic though slightly comic and disrespectful imaginary portrait of the Pre-Raphaelites' bugbear, whose bugbearishness was embodied in the Brotherhood's very name: Raphael.

TECHNOLOGY SAVES ITS USERS' TIME. Beardsley was impelled towards 'modern life', black and white, and confidence in technological processes to reproduce his work by the nature not only of his genius but of his disease. He had time neither to learn nor to exercise the handicraft of oil painting. Instead, urgency drove him to

enlarge the expressive range of the medium already at his hand. He built up his pictures in pencil, amending them on the same piece of paper (as though by saving paper he could save his life energy) until the whole surface of the paper 'became', as Ross recorded, 'raddled from pencil, indiarubber, and knife'; then he inked over the raddled surface, and erased afterwards any pencil marks that still showed. From his battles with the paper he conceived, I think, a symbolic interpretation of his designs themselves: their drama and economy, expressed as white encroaching on black or as black threatening to engulf white, came to represent the encroachment of tuberculosis on Beardsley's lungs and the threat that death would swallow up his art.

It was his own allegory he drew (probably in 1891) in *Withered Spring*, where a Pre-Raphaeliteish figure sits sad in front of a closed gate marked '*Ars longa*'. (The second half of the Latin tag, a translation from Hippocrates, is '*vita brevis*'; the meaning is that art takes a long time to learn and practise, whereas life is short.) In his haste, his own art moved from allegory to condensed and cogent imagery. The image of the embryo, which peoples many of his pictures, is a self-portrait. The youngest form of human life, it looks already wizened: thus was his life telescoped. In one of his *Bon-Mots* grotesques, the embryo's bald, wise-old-man's head protrudes from a body wearing full evening dress. In another, by almost heraldic imagery, the top of the embryo's skull is cut off and it has become a flower pot, out of which grows a skeleton.

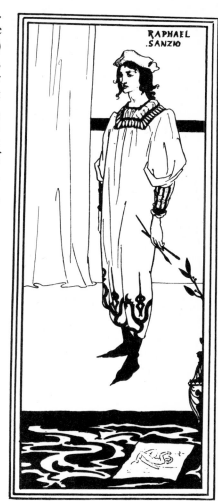

Beardsley's picture of Raphael, done probably about 1892 and perhaps to mark his break with the aesthetics of the Pre-Raphaelite Brotherhood.

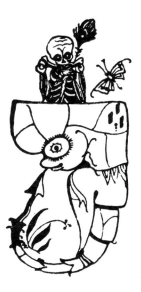

Two of Beardsley's 'grotesques' for the *Bon-Mots* series, published in 1893 and 1894. The drawing on the left is from the second volume (Lamb and Jerrold), that on the right from the first (Sydney Smith and Sheridan).

55

(*Opposite, left*) Beardsley's picture of his fellow consumptive and fellow great artist, Weber (1786–1826).

(*Opposite, right*) Walter Sickert's painting of Beardsley as he left Hampstead church after the ceremonial unveiling there, in 1894, of a bust of Keats.

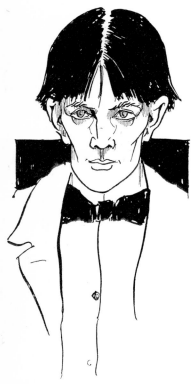

The self-portrait Beardsley gave Ross, a year after describing himself, at eighteen, as having 'a vile constitution, a sallow face and sunken eyes, long red hair, a shuffling gait and a stoop'.

Beardsley's sympathy for Raphael rested not only on the Pre-Raphaelites' lack of it but on the fact that Raphael died young. The companion piece to his *Raphael Sanzio* is a romantic portrait of Carl Maria von Weber, the composer of enchanted operas who died in 1826 not merely young (thirty-nine) but of tuberculosis.

The same identification with tubercular artists bound him to John Keats, who died at twenty-five in 1821. Beardsley correctly predicted to his acquaintance Penrhyn Stanlaws: 'I shall not live longer than did Keats.' It was Keats's epitaph for himself, 'Here lies one whose name was writ in water', that Beardsley turned to sardonic purpose when he called anecdotal oil paintings and descriptive watercolours pictures 'told in oil or writ in water'. In July 1894 he attended the ceremonial unveiling of a bust of Keats in Hampstead Church. After the ceremony, his friend Walter Sickert painted from memory a full-length portrait (reproduced in *The Yellow Book* of July 1894 and now the property of the Tate) terrifying in the nakedness of its symbolism: formally and fashionably dressed, lean with illness, Beardsley is leaving Hampstead Church through the graveyard.

Achievement regularly reminded Beardsley how little time he had for further achievement. To the report he gave King, in 1891, of his triumphant first meeting with Burne-Jones he added: 'I am now eighteen years old, with a vile constitution, a sallow face and sunken eyes, long red hair, a shuffling gait and a stoop.' That pen-written self-portrait he confirmed, in the next year, by the pen-drawn self-portrait he gave to Robert Ross. (Ross recorded Beardsley's hair not as red but as brown. Both Haldane MacFall, who published a biography of Beardsley in 1928, and Max Beerbohm made it 'tortoiseshell'.)

To Clark, in 1891, Beardsley sent a versified but undisguised account of his terror. 'The lights are shining dimly round about, The Path is dark, I cannot see ahead', the first of its three quatrains begins. The last admits:

> *The night is dark and strength seems failing fast*
> *Though on my journey I but late set out.*
> *And who can tell where the way leads at last?*
> *Would that the lights shone clearer round about!*

The poem is a clue to the picture Beardsley was working on, of which he gave Clark word in the same letter: '*Hamlet following the ghost of his father* or, as I have it in Latin, *Hamlet patris manem sequitur* (a stunning design, I can tell you).'

It is in fact a deeply Burne-Jones-like design, which is surely why Beardsley picked the Pre-Raphaelites' favourite word of slang praise, *stunning*, to describe it. Why he picked the Latin language for the title (which he lettered at the bottom of the drawing) of an illustration to an English play about a Danish prince is harder to guess but not im-

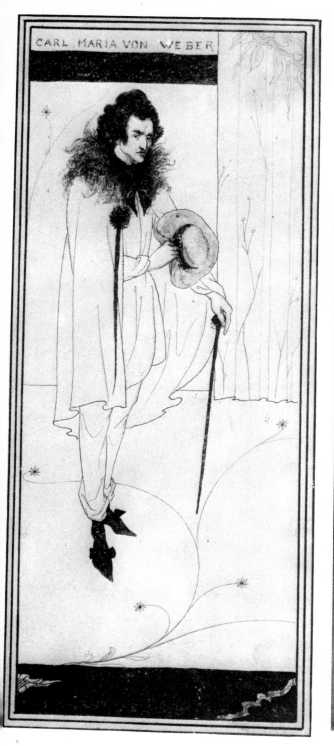

CARL MARIA VON WEBER

Sickert

Beardsley expressed his feelings towards his father and towards the illness he shared with his father in his pencil drawing of 1891, *Hamlet Following the Ghost of his Father.*

possible. The word *ghost* is well veiled behind the Latin *manes*, which has no connection with it in sound or etymology and for which the regular school-classics-lessons translation was anyway *shade* rather than *ghost*. Beardsley was, I think, suppressing, perhaps unconsciously, the connection between his *Hamlet* illustration and another play with a Scandinavian setting which he had recently illustrated and which was still much in the public's scandalized thoughts. The hero of Ibsen's *Ghosts* is doomed because his father has transmitted a venereal disease to him. By amalgamating Ibsen's hero with Shakespeare's, who dies young because his father has left him the legacy of a murder to avenge, Beardsley was accusing his father of transmitting tuberculosis to him, thus setting him on the path where, as his poem says, 'I cannot see ahead'. His *Hamlet* picture makes it plain there *is* no path ahead: no alternative to following the ghost into death.

The strength of the emotions he incarnated in his *Hamlet* accounts for Beardsley's delight at its publication, which he considered the true beginning of his career. In the second half of 1891 King took charge of several Beardsley drawings and of Burne-Jones's letter to him. Using the letter as a testimonial, he tried to find buyers for the pictures. Beardsley authorized him to take 10s., if it were offered, for the *Hamlet* and asked him, should he make a sale, to fake his signature (in the form 'A.B.' – the trade mark was not yet invented) on the picture.

Instead, King offered to publish *Hamlet* (which was in pencil) in *The Bee*, the magazine of Blackburn Technical Institute. Beardsley accepted with gratitude and another act of recognition of the nature of his own talent: 'As it is in very distinct and well-defined black and white it should reproduce fairly well.' Reproduced, by lithography, in light red, *Hamlet* became the frontispiece of the issue of November 1891 – which was published late. Beardsley received his copy of the magazine by post on Christmas morning.

With the picture King published a Note, by himself, prophesying Beardsley's importance to 'the domain of art when the twentieth century dawns'. Beardsley wrote straight off to express his pleasure – through, however, a flight of facetious fancy that expressed also his uncertainty of living into the twentieth century. 'On reading your "notice on the illustration", I scarcely knew whether I should purchase to myself a laurel wreath and order a statue to be erected immediately in Westminster Abbey; or whether I should bust myself.'

He had (as his half-formed pun on the word *bust* confirms) remembered (or remembered at second hand, from family folklore, as no doubt his mother did when she recorded it) the question he asked as a child in Westminster Abbey, whether he should have a stained glass window or a bust. But such a memorial was to be erected, of course, only 'when I am dead'.

The second time that this fantasy, which tries to accept posthumous fame as compensation for early death, occurred to Beardsley, the choice was only between a statue and, in the half-pun, a bust. The stained glass has vanished. By 1891 Beardsley had already made his choice between coloured and uncoloured art.

WITHIN A YEAR of King's publishing *Hamlet* in an obscure, half-private magazine, Beardsley was in a position to suggest a commission for King to write for a professional one. He did it in what he apologetically called an 'outrageously egotistical letter' written at midnight in December 1892, listing the offers he now had from publishers and commenting: 'But I don't know how I'm to find time for them all.'

Through his Pimlico vicar and patron, Beardsley had met Aymer Vallance ('dear Aylmer Vallance', as Wilde was to write of him in 1900, inserting the expected *l* into the first name which in unconventional fact lacked it). A writer and designer (of, for example, four patterns for the backs of playing cards, which Beardsley published in *The Yellow Book* of July 1894), Vallance worked with William Morris at the Kelmscott Press, which Morris had started in 1890, and his first thought on Beardsley's behalf was to get him a commission from the same source. Beardsley carefully prepared samples of his work, sending Vallance 'a much better pull than the one I showed you on Thursday' of a zinc process picture that Vallance was to show to Morris. But Morris disliked Beardsley's work.

Next, Vallance introduced Beardsley to Robert Ross, who was then in his early twenties: a Canadian (by birth), a literary journalist and a close friend ('my dearest Bobbie . . . You dear boy') of Oscar Wilde. Eleven years after Beardsley's death Ross published his affectionate and appreciative memoir of him, to which was appended a comprehensive 'iconography' (i.e. *catalogue raisonné*) of Beardsley's *œuvre* by Vallance.

At their first meeting, at Vallance's rooms on 14 February 1892, Ross went through Beardsley's portfolio and asked to buy one of the pictures. Thereafter he kept up the habit; and in his memoir he entered an affectionate complaint against a corresponding habit in Beardsley, who, when he called on friends who owned early examples of his work, 'would destroy these early relics and leave a more mature and approved specimen of his art'. 'Some of us', Ross continued, 'were eventually obliged to lock up all early examples.'

Of the first Beardsley Ross tried to buy, *The Procession of Jeanne d'Arc*, Beardsley had to draw a replica, which he delivered to Ross a few weeks later, because the original version already belonged to Frederick H. Evans, a bookseller and an amateur portrait photographer, one of whose subjects was Beardsley. Beardsley was in the

Photograph of Robert Ross (1869–1918), friend and literary executor of Oscar Wilde, friend and early patron of Beardsley, who met him on St Valentine's Day, 1892.

LE DÈBRIS D'VN POÈTE.

Beardsley's comment on insurance clerking.

habit of visiting Evans's bookshop in Queen Street, Cheapside, during his lunch-hours from the insurance office in Lombard Street, and he sometimes bartered drawings with Evans in exchange for books.

In his urgency to store up an immortal life for himself in his art, insurance clerking was for Beardsley a sad and, his own life being so patently uninsurable, ironic instrument of his dear time's waste. This he expressed in his picture of a clerk who has some of the bodily pathos of a clown, which he called (or miscalled, since his 'uncanny knowledge of French' did not stretch to putting the right accent on *dèbris*) *Le Dèbris d'un Poète*.

His French was, however, socially fluent. In 1892 his annual holiday from the office was set in June, and he used it to make his first visit to Paris. He took with him about twenty drawings in his 'new style'. To his former headmaster he described them as 'extremely fantastic in conception but perfectly severe in execution'. To Clark he gave a description, less circumspect, of their subject matter: 'quite mad and a little indecent. Strange hermaphroditic creatures wandering about in Pierrot costumes or modern dress; quite a new world of my own creation.' These he showed to Puvis de Chavannes, the painter of gentle allegories who was then a great name in France and whose praise Beardsley found it worthwhile to quote in England because he was president of the Salon des Beaux-Arts. The piece of praise Beardsley quoted most widely was, however, more equivocal than he noticed. Puvis introduced him to a fellow painter as 'un jeune artiste anglais qui fait des choses étonnantes'.

It was in Evans's bookshop that Beardsley achieved deliverance from clerkship and revenge on William Morris. Beardsley was in the shop when another customer, the publisher J. M. Dent, disclosed to Evans his plan for an illustrated edition of Sir Thomas Malory's classic version in English prose of the King Arthur stories, which had been first printed by William Caxton in 1485, the *Morte d'Arthur* or, as the Dent edition was with pedantic archaism to have it, *Le Morte Darthur*. Dent's aim was to produce a fake Kelmscott Press book. Printing from line block, whereas Morris used hand-engraved wood, he intended to cash in on the medievalizing vogue Morris had created among book buyers but to avoid the trouble and expense Morris went to. He was in search of a designer able to take on the Arthurian subject in a sufficiently Burne-Jonesish manner but unable to exact a Burne-Jones-size fee.

Evans suggested Beardsley. Dent demanded that he produce one of the illustrations, on speculation and without payment, as a specimen. Beardsley drew *The Achieving of the Sangreal* and got the commission, though he had delivered half the whole work before Dent actually provided a contract. Beardsley expected to take a year over

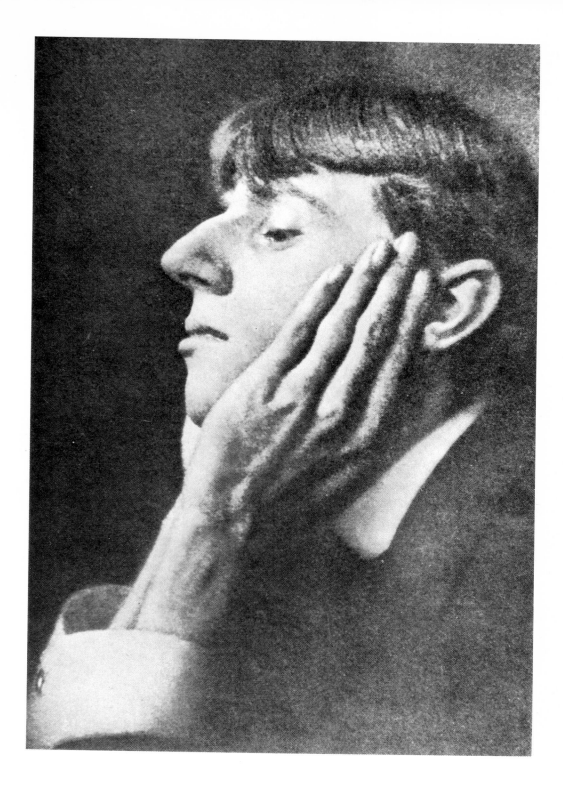

Through the bookseller-photographer Evans, Beardsley secured a commission to produce an illustrated edition of Malory's *Le Morte Darthur* in the manner of William Morris.

One of Beardsley's chapter headings for *Le Morte Darthur*. The edition was published in parts in 1893–4.

Book ij. Chapter j.

OF A DAMOSEL WHICH CAME GIRT WITH A SWORD FOR TO FIND A MAN OF SUCH VIRTUE TO DRAW IT OUT OF THE SCABBARD.

AFTER the death of Uther Pendragon reigned Arthur his son, the which had great war in his days for to get all England into his hand. For there were many kings within the realm of England, and in Wales, Scotland, and Cornwall. So it befell on a time when King Arthur was at London, there came a knight and told the king tidings how that the King Rience of North Wales had reared a great number of people, and were entered into the land, and burnt and slew the king's true liege people. If this be true, said Arthur, it were great shame unto mine estate but that he were mightily withstood. It is truth, said the knight, for I saw the host myself. Well, said the king, let make a cry, that all the lords, knights, and

some four hundred designs (both proved underestimates) and to be paid either £200 (his estimate to King) or (his later estimate to Clark) £250. Beginning in June 1893 and continuing into 1894, the book was issued in parts, which built up into two volumes.

The *Morte Darthur* decorations are a mixture of Burne-Jonesism and incipient Beardsleyism, as though the enforced return to the influence of Burne-Jones melted the Beardsley identity he had already created and left him to re-form it in the course of the work. His grotesques for the three *Bon-Mots* volumes, also for Dent and also issued during 1893–4, are wholly Beardsley. But both commissions, by their size, drove him to plunder the imagery of the past. For the *Bon-Mots* pictures he resurrected the Greenaway girl and divested her of any last pretension to innocence by placing her in the company

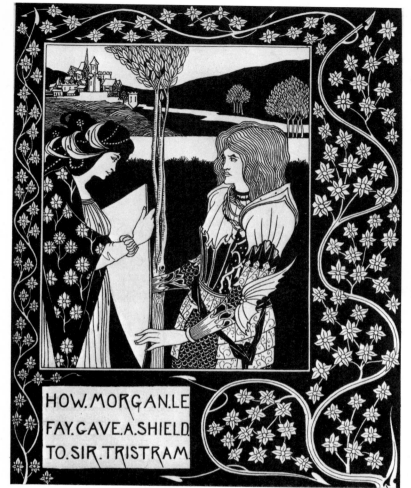

HOW. MORGAN. LE
FAY. GAVE. A. SHIELD.
TO. SIR. TRISTRAM.

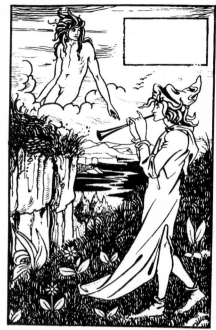

In this chapter heading in *Le Morte Darthur* Beardsley, who found the commission laborious, fell back on the pied piper image he had drawn at Brighton Grammar School.
In Victorian England the Arthurian stories were taken over by Tennyson in literature and by Burne-Jones in painting. The *Morte Darthur* commission revived the influence of Burne-Jones on Beardsley.

of monsters; for a chapter heading in *Le Morte Darthur* he drew a piper who had previously decorated the programme of Brighton Grammar School's production of *The Pay of the Pied Piper*.

On the strength of the *Morte Darthur* commission Beardsley gave up, in the autumn of 1892, both his evening attendances at art school and his job at the insurance office, where he had been, he wrote to King, a 'case of the □ boy in the ○ hole'. He resigned first and, as he reported, 'informed my people of the move afterwards'. His parents' immediate reaction consisted of 'ructions' but, Beardsley cynically continued, 'of course now I have achieved something like success and getting talked about they are beginning to hedge and swear they take the greatest interest in my work.' Evidently Beardsley was frightened, whether of King's reaction or of his own emotions, when

he noticed that his 'they' had included his mother in his cynicism. Re-allocating his blame, in accordance with Ellen Beardsley's mythology and his own state of mind as evidenced in his *Hamlet* picture, he added: 'This applies however principally to my revered father.'

Vallance, meanwhile, was getting Beardsley yet more 'talked about'. He introduced him and his portfolio to C. Lewis Hind, who was on the point of editing a new monthly art magazine, *The Studio*. By December 1892 Beardsley was 'practically on the staff' of the not yet published magazine and it was in this capacity that he tried to arrange for King to contribute an article on the training scheme operated at Blackburn Technical Institute.

However, by February 1893 Hind was editing not *The Studio* but the *Pall Mall Budget*, where he employed Beardsley (who made 'about £10 a week' from it) to draw, against the grain of his talent, topical caricatures. Hind did, however, inspire Beardsley by taking him to the Mint to see the designs for a new coinage. Beardsley produced and Hind published alternative versions, purportedly submitted by various artists, of the monarch, whose head is on the recto of British coins, and of Britannia who then sat on the verso. Beardsley's two Britannias were in the manner of Burne-Jones and of Sir John Millais. Walter Crane's monarch was, in Beardsley's version, Demos (the people), and Whistler's monarch was (as embodied in his emblematic signature) Whistler. The most inspired of Beardsley's designs, however, Hind dared not publish. It was a monarch in the manner of Edgar Degas and consisted of Queen Victoria as a Degas ballet dancer.

In April 1893 *The Studio* was launched: and with it Beardsley. Its front cover, printed on dark green, was designed by Beardsley; and its main article, commissioned by Hind before he shifted jobs, was *A New Illustrator: Aubrey Beardsley*, by the U.S.-born artist and critic Joseph Pennell, to whom Beardsley expressed his enduring gratitude in 1897 by dedicating to him his collection in volume form, *A Book of Fifty Drawings*.

Pennell's article in *The Studio* was accompanied by reproductions of ten Beardsley pictures, including Burne-Jones's *Siegfried*, Ross's replica *Jeanne d'Arc* and, by way of advance publicity, four of the *Morte Darthur* designs.

'Clark, my dear boy,' Beardsley wrote facetiously but truthfully to his school friend, 'I have fortune at my foot.' He was awaiting the appearance of the first *Studio* in April 1893 and of the Dent *Morte Darthur* in June. His twenty-first birthday was not till August. The *Morte Darthur* was already subscribing, and Beardsley was able to report Morris's reaction and his own counter-reaction: 'William Morris has sworn a great oath against me for daring to bring out a

For the *Pall Mall Budget* in 1893 Beardsley satirically redesigned the coin of the realm, replacing Queen Victoria's head by this picture of her à la Degas (which the magazine did not publish).

Beardsley designed the cover of this first issue of *The Studio*. Inside, Pennell's article in praise of Beardsley was accompanied by reproductions of ten of Beardsley's pictures.

book in his manner. The truth is that, while *his* work is a mere imitation of the old stuff, mine is fresh and original.'

One of the Beardsleys reproduced in the first *Studio* was an illustration to Oscar Wilde's *Salomé*. Wilde wrote the play in French for Sarah Bernhardt, who was rehearsing it in Paris in 1892 when the French censor intervened with an embargo on biblical characters' being represented on the stage. Early in 1893 Wilde published the French text in Paris. It was from that edition that Beardsley illustrated the climactic scene where Salomé kisses the Baptist's severed head. He lettered on the picture her words 'J'ai baisé ta bouche, Iokanaan,

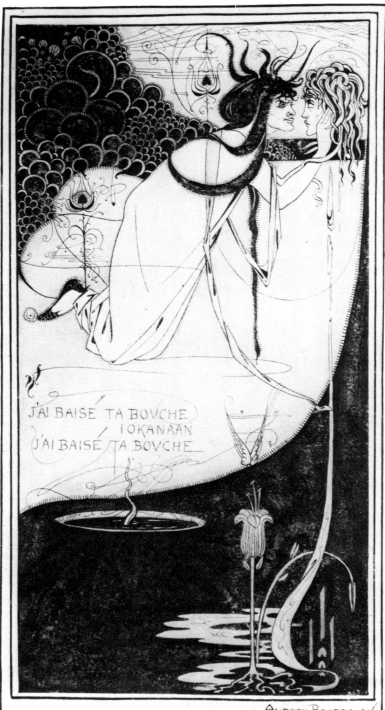

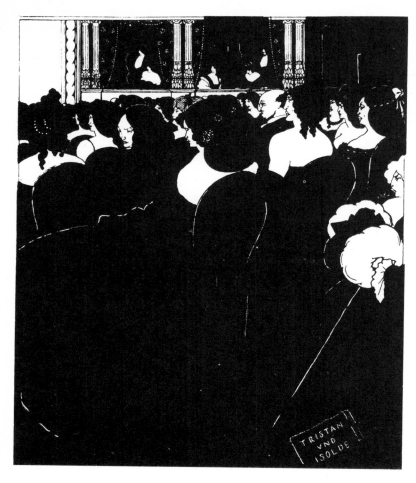

(*Opposite*) Beardsley's first version of this illustration to *Salomé*. It was drawn to Wilde's original (French) text, and was published with Pennell's article in the first issue of *The Studio*, 1893.

The Wagnerites, published in *The Yellow Book*, Vol. III, October 1894.

j'ai baisé ta bouche'. He was putting in a public bid for the job of illustrating the English edition.

 Hoping perhaps to secure it or perhaps merely to scandalize the recipient, he sent King a postcard in spring 1893 announcing: 'I'm off to Paris soon with Oscar Wilde.' In fact he went, in May, with Elizabeth and Joseph Pennell. In Paris he drew a portrait of Pennell as a gargoyle on the roof of Notre Dame and, in Pennell's company, attended a performance of *Tristan und Isolde* (a talismanic opera for Beardsley, who made a decorated cover for his own copy of the vocal score) that inspired his great picture *The Wagnerites* – whose fame, after its *Yellow Book* publication in 1894, surely in turn inspired the title of Shaw's book *The Perfect Wagnerite* of 1898.

 By mid-1893 Beardsley was besieged with work. He drew a frontispiece for a translation (by, under a pseudonym, his and Wilde's friend More Adey) of a play by the Norwegian B. Björnson and, in

Beardsley visited Paris in 1893 with Pennell, whom he drew as 'the devil of Notre Dame'.

There was a vogue, in England in the nineties, for Scandinavian literature. Beardsley drew this frontispiece for a translation from the Norwegian, published in 1893. He signed it with a monogram modelled on Dürer's.

his new artistic confidence, signed it with a monogrammed 'A.B.' modelled on the 'A.D.' monogram of Albrecht Dürer, Dürer being one of the few acknowledged Old Masters whose reputation rested at least as much on his black and white work as on his paintings.

In his new financial confidence, he set up house, with Mabel. 'We are', he wrote to an acquaintance, 'always at home on Thursday afternoons.' In the Post Office directory Mabel appeared as the householder, perhaps because the move was made before Aubrey was twenty-one (then the age of majority), perhaps because her income from teaching was the most reliable in the family. The venture had a

safety net in the form of the £500 from Sarah Pitt that Mabel had inherited, and Aubrey would inherit, at twenty-one.

The new home, 114 Cambridge Street, Pimlico, represented a return to the street of the Beardsleys' last but one lodging and of 'The Cambridge Theatre of Varieties'. There was in Beardsley's behaviour a small but very meaningful motif of going back to places – as though by going back in terms of place he could go back in time and thereby prolong his life. The pattern was set for him when he was sent to school in Brighton in the road where he had been born. As an adult he repeated the pattern by choice. He probably went back fairly often to Brighton. ('I was stopping down at Brighton,' he wrote to a magazine editor in 1893, explaining his delay in returning the text of a story he was to illustrate.) In 1896, very ill, he went back to Epsom – and stayed at the Spread Eagle, which is at the top of Ashley Road where he had lived as a child. From Epsom he planned another going back: to Brighton. This his doctor forbade, and he moved instead to a boarding house at Boscombe, where he received the form for his entry in *Who's Who* and, in filling it in, disclosed the unconscious purpose of his goings back: he falsified his date of birth by two years, as if to give himself two years more alive.

The second half of 1893 Beardsley spent, at his new address, 'working off arrears for Dent' and starting his new major commission. He had got the illustrating of the English *Salome*. (He continued, however, to think of it in its original French version. He always spelled it *Salomé*.) The translator was Wilde's sweetheart, Lord Alfred (Bosie)

114 Cambridge Street, Pimlico, the house Mabel and Aubrey Beardsley moved into in mid-1893.

The hotel in Epsom where Beardsley, very ill, stayed in 'two palatial rooms' in the summer of 1896. It is at the top of the road where he lived as a child.

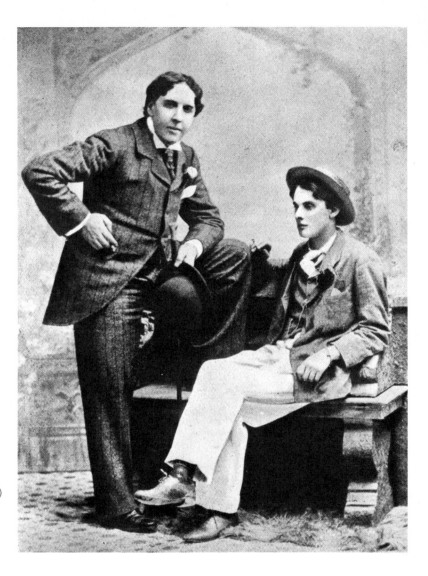

Oscar Wilde and Lord Alfred (Bosie) Douglas photographed together. Wilde's French play *Salomé* was translated (unsatisfactorily, Wilde thought) by Douglas.

Douglas. The publisher was John Lane of the Bodley Head, who was at that time in partnership with Elkin Mathews. By the autumn Beardsley had formed the impression that Lane, in his negotiations about another publishing project (which came to nothing), was be- having 'treacherously' towards both Beardsley and the painter William Rothenstein (who had become a friend of Beardsley's and who now gave him a book of Japanese erotic prints with which Beardsley decorated his new bedroom). Wilde's view of his publisher was publicly declared in 1895, when he named the manservant in *The Importance of Being Earnest* Lane.

Cultivated, dandified and a born master of high camp, Beardsley fitted easily and wittily into Wilde's ambience. By the winter of 1893 he was 'My dear Aubrey' when Wilde invited him, with Ross, to dine at Kettner's. As Lord Alfred Douglas recorded, Beardsley's literary taste provoked Wilde to a witty demonstration of one of the rare blind spots in his own: Beardsley declared his love of Alexander Pope; Wilde commented that there were two ways of disliking poetry, one being to dislike it and the other being to like Pope. Beardsley shared Wilde's generosity of temperament and his sense of a duty to shock the holders of irrational opinions. Their sexual tastes were compatible though not identical. Beardsley's, which may well have been expressed chiefly in fantasy, were probably for the most part heterosexual, perhaps tinged with transvestism. Performing his duty to shock Lane, he wrote to him: 'I'm going to Jimmie's' (the St James's Restaurant) 'on Thursday night dressed up as a tart and mean to have a regular spree.'

The plans for *Salome* stumbled, momentarily, on a literary lovers' quarrel between Wilde and Douglas. Wilde disliked and partly rewrote Douglas's translation. Beardsley, as illustrator, was in the middle. He took up what Shaw called his pose as 'a reveller in vices of which he was innocent' when he reported 'the *Salomé* row' to Robert Ross (who, not being innocent of those 'vices', was temporarily in Switzerland in refuge from the persecutory laws against homo-sexual men which were then in force in Britain): 'I can tell you I had a warm time of it between Lane and Oscar and Co. For one week the number of telegraph and messenger boys who came to the door was simply scandalous.' Wearily he added, of Oscar and Bosie (whom he habitually spelled as he was pronounced, with a *z*): 'Both of them are really very dreadful people.'

The English *Salome* was, however, published in February 1894, the quarrel resolved by the naming of Douglas in the book not as translator but as dedicatee. Beardsley drew, besides motifs for the cover and borders for the title page and the list of pictures, thirteen illustrations, one of them what he called a 'redrawn and immensely improved' version, retitled *The Climax*, of the French illustration in *The Studio*. (After it had been reproduced in *The Studio*, Beardsley tinted the original of the earlier design green.) Two further *Salome* illustrations were not in the book but were in the portfolio edition of the pictures that Lane published, after Beardsley's death, in 1907.

Of the designs that were published in the volume of 1894, Lane had expurgated two, and a third was a completely redesigned version of *The Toilet of Salome*; in the original version one naked boy attendant is masturbating while eyeing another. About the title-page design, Beardsley agreed that it would have been 'impossible' without expurgation, because 'booksellers couldn't stick it up in their

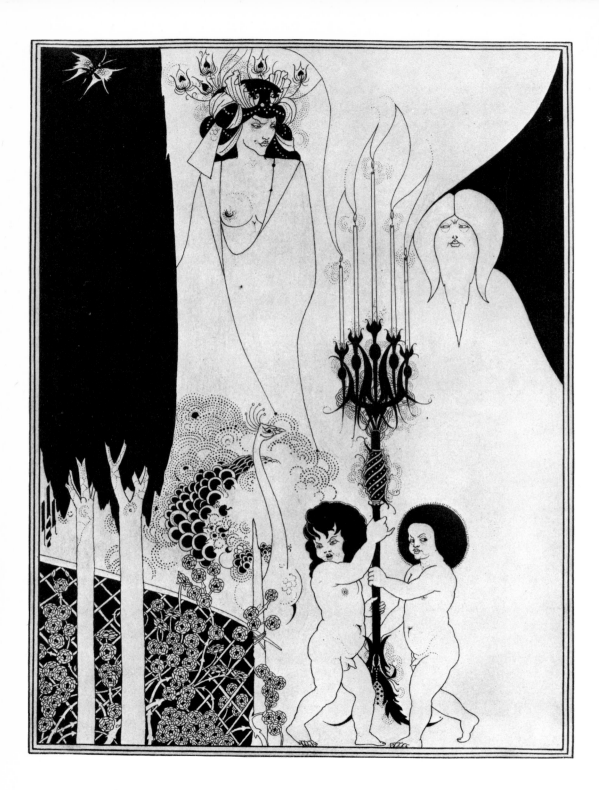

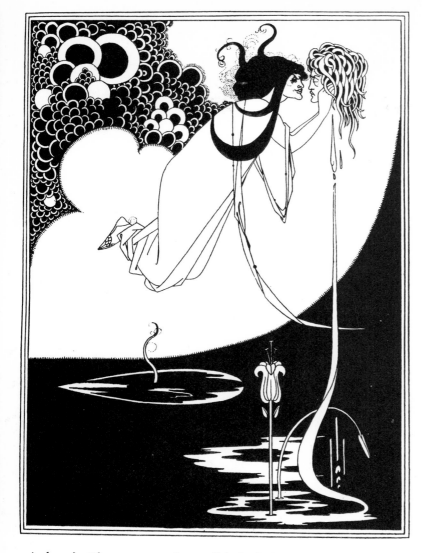

When he illustrated the English *Salome*, Beardsley produced this 'redrawn and immensely improved' version of the illustration published in the first *Studio*.

windows'. The expurgated proof (which later belonged to Frank Harris) of the other expurgated design, *Enter Herodias*, Beardsley inscribed to an Alfred Lambart, with the comment:

> *Because one figure was undressed*
> *This little drawing was suppressed.*
> *It was unkind, but never mind,*
> *Perhaps it all was for the best.*

Certainly it was all, despite expurgation, for confirming the notoriety of both Beardsley and Wilde. Four of the *Salome* pictures contain, in sly disguises, portraits of Wilde.

(*Opposite*) In this illustration, *The Eyes of Herod*, to the English edition of Wilde's *Salome*, Beardsley drew Wilde as Herod.

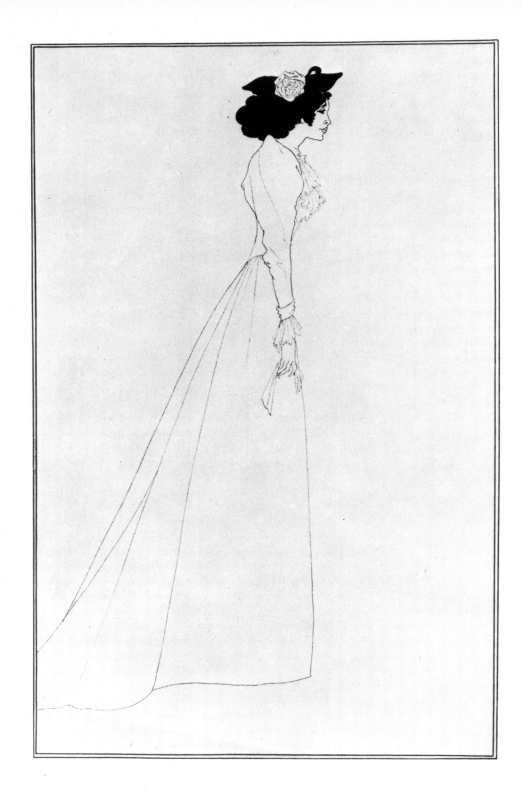

IN FEBRUARY 1894 OSCAR WILDE sent a note to Mrs (Beatrice Stella) Patrick Campbell, who was playing at the St James's theatre in A.W. Pinero's *The Second Mrs Tanqueray* (in which, incidentally, *Mr* Tanqueray's name is Aubrey), asking if he might come round after Act III and introduce to her 'Mr Aubrey Beardsley, a very brilliant and wonderful artist'. Soon afterwards Beardsley wrote to her to arrange a sitting. His delicate and daringly mannerist portrait of her as Paula Tanqueray belonged to Wilde (it was included in the sale of his possessions after his bankruptcy and is now in the National Gallery, Berlin); and, to complaint from critics of its 'impossible waist, and a yard and a half of indefinite skirt', it was one of four Beardsley pictures (the cover apart) published in the first volume of *The Yellow Book*.

The Yellow Book, perhaps the greatest *succès de scandale* in the history of journalism, the crystallization of the nineties and the finest (because designed by himself) showcase for Beardsley's genius, was conceived on the foggy afternoon of 1 January 1894, after Mabel and Aubrey Beardsley had lunched at the home, in the Cromwell Road, Kensington, of Henry Harland and his wife. Harland, a U.S. expatriate and a gently witty and camp novelist, was tubercular and had first met Beardsley in the waiting-room of the specialist they both consulted.

Although it was a magazine ('An Illustrated Quarterly'), *The Yellow Book* looked, as its name (Beardsley's invention) implies, like a book. Roughly eight and a quarter by six and a quarter inches, and an inch or more thick, the volumes had hard yellow covers that made them, by intention, resemble French novels of the period. Beardsley's cover design (new for each volume) was printed in black on the front, together with the title and the price (5s.); his decorations on the spine; and on the back, between two bands of Beardsley decoration, the contents list, which on the first volume was divided into 'Letterpress' and 'Pictures', a formula changed, from the second volume on, to 'Literature' and 'Art'. Inside, each plate had its own flimsy protective sheet. The publishers who took on the project and took on also Harland and Beardsley as, respectively, literary and art editor were Elkin Mathews and John Lane. (Beardsley put Mathews into his prospectus for the magazine, as a wrinkled and spectacled Pierrot.) Copeland & Day, of Boston, were also named on the front cover, as the U.S. publishers. After the first two volumes, Mathews and Lane were, as Beardsley put it, 'at last divorced', and Lane continued *The Yellow Book* and the Bodley Head imprint on his own.

The first volume appeared in April 1894. Its contents included Henry James's story *The Death of the Lion*; a Beerbohm essay in praise of cosmetics; verse by Gosse and by Arthur Symons; a play by George Moore and John Oliver Hobbes (Pearl Craigie) in collaboration; drawings by the President of the Royal Academy, Sir Frederic

(*Opposite*) Oscar Wilde introduced Beardsley to Mrs Patrick Campbell. Beardsley drew this picture of her in the role of Paula Tanqueray and published it in Volume I of *The Yellow Book*.

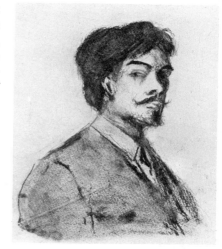

This uncharacteristic drawing by Beardsley, art editor of *The Yellow Book*, of Henry Harland, its literary editor, was owned by John Lane, its publisher.

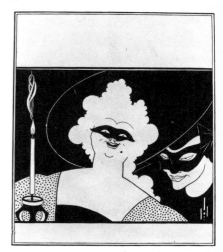

The Beardsley picture that appeared, in black stamped on yellow, on the front cover of Volume I of *The Yellow Book*, April 1894.

Beardsley's picture *The Fat Woman*. Lane would not let it into *The Yellow Book* because it caricatured Whistler's wife. It was published in another magazine, *To-Day*, in May 1894.

Sargent's drawing of Henry James, reproduced in *The Yellow Book*, Vol. II. 'Will you', Beardsley wrote to James, 'give me authority to go to your rooms and take it away . . .?'

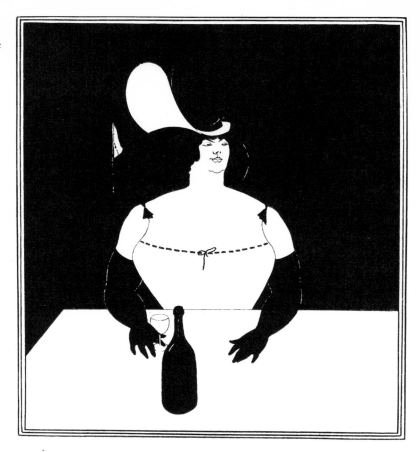

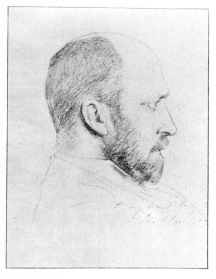

Leighton; a painting by Sickert; and eighteen pages, grouped at the end, of publishers' and booksellers' advertising. (Dent advertised the Beardsley *Morte Darthur*.) Despite Beardsley's wheedling ('Yes, my dear Lane, I shall most assuredly commit suicide. . . . I shall hold demonstrations in Trafalgar Square') the contents did not include his picture *The Fat Woman*. Lane banned it because it was a caricature of Whistler's wife.

Besides producing his own pictures for *The Yellow Book* and carrying out his editorial work, which included borrowing from Henry James the portrait of him by J. S. Sargent that was reproduced in the second volume (as a *douceur* Beardsley gave James one of his drawings of the French actress Réjane), Beardsley went on taking outside commissions. 'I feel', he wrote to a Chicago publisher early in 1894, 'that Poe's tales would give me an admirable chance for picture making.' He knew his own talent. The complete ten-volume edition of the works of E. A. Poe that was published during 1894–5 contained four of his most masterly and surreal expeditions into the

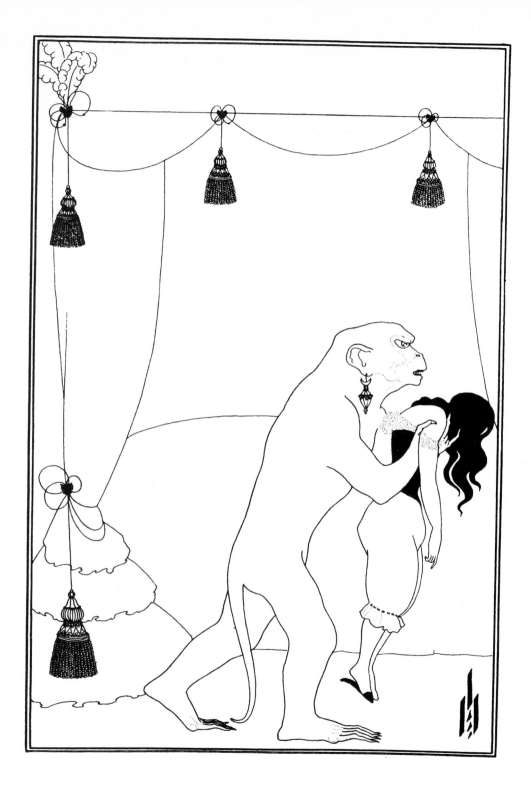

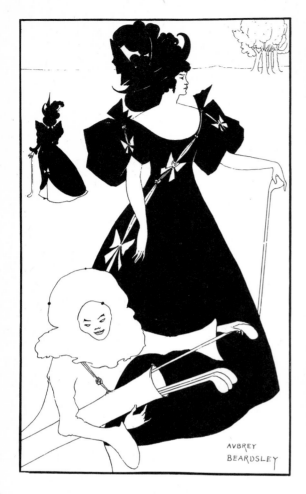

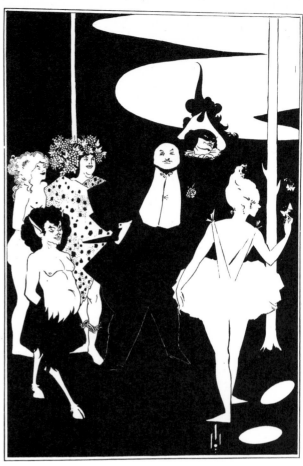

AVBREY
BEARDSLEY

(*Above*) Beardsley's design (1894) for an invitation card for a women's golf club in Mitcham, Surrey. It is in effect a fashion plate: the second woman shows the back view of the first.

(*Above, right*) The Davidson frontispiece where Beardsley depicted Wilde and Harris. The others have been identified as Harland, Mabel, Richard Le Gallienne (once satirized by Beardsley as 'Richard Le Philistienne') and Adeline Genée.

(*Opposite*) *The Black Cat*: Beardsley's genius for the macabre combined with Poe's.

macabre. He designed the cover for a Cambridge undergraduate magazine (1894) run by Maurice Baring and a collateral descendant of Jane Austen, R. Austen-Leigh; invitation cards and book plates; and the frontispiece for a volume (1894) of John Davidson's plays, in which he depicted Harland as a faun, Mabel Beardsley naked, Wilde as a Bacchus with bound ankles, the theatre manager Augustus Harris in vulgarly expansive and studded evening dress, the *Yellow Book* writer Richard Le Gallienne in *commedia dell'arte* costume, and the dancer Adeline Genée.

Mabel's presence perhaps celebrated the beginning, in 1894, of her professional career in the theatre. (She appeared first at the Haymarket and then went on tour in Wilde's *A Woman of No Importance*.) Beardsley rebutted a charge that it was in bad taste to introduce portraits into the picture by explaining in a letter to the press that 'one of the gentlemen' depicted was self-justifyingly beautiful and that

Some of the monogrammed keys, playing on the authors' initials, which Beardsley designed for the Keynotes series of books.

Augustus Harris owed him, Beardsley, half a crown. Beardsley had paid for but not got a seat at Covent Garden.

For a Davidson novel (1895) he drew the delicately flagellatory *Earl Lavender* frontispiece. For a novel called *Keynotes*, published at the end of 1893, he drew a title page and a door key embodying the author's monogram. The idea developed, during 1894–5, into a Keynotes series of titles, each with corresponding decoration by Beardsley. The Keynotes volumes included one by Harland and *The Dancing Faun*, by Florence Farr, for which Beardsley drew a faun with a resemblance to Whistler.

It was for Florence Farr in her actor-manager capacity that Beardsley designed in 1894 a blue and green poster for a double bill consisting of a play by John Todhunter and a curtain raiser by W. B. Yeats. The same poster was then used to advertise the next play in the season, the first production of Shaw's *Arms and the Man*.

Self-defence in the press became part of Beardsley's vocation. For having put on the title page of the first *Yellow Book* a woman surreally standing at an upright piano in a field he defended himself by inventing a musicologist and quoting from him a spurious precedent from the life of Gluck. He repeated the offence in a bolder design – for a commission

(*Opposite*) Beardsley's poster for the season at the Avenue Theatre, 1894. Productions included a John Todhunter/W. B. Yeats double bill and Shaw's *Arms and the Man*.

Beardsley's punning poster design to advertise Singer sewing machines.

(*Opposite*) Beardsley's self-portrait as a monstrous invalid, an infant voyeur fully aware that his bed is hung with phallic symbols and topped with breasts (both in decorative forms borrowed from the Royal Pavilion).

that so astonished him that he wrote to Lane: '*Singer's Sewing machines*!! have just commissioned a poster. What next?' His poster pianist is a pun, since she is also a singer; and Beardsley increased the surrealism of her presence in a field by providing her also with a chair.

In the third (October 1894) *Yellow Book* he defended himself in advance. He published a portrait of Mantegna by Philip Broughton. Critics preferred it to the Beardsleys in the same volume (which included *The Wagnerites* and the portrait of himself in a curtained bed that discloses both his invalidism and the child-voyeur sources of his

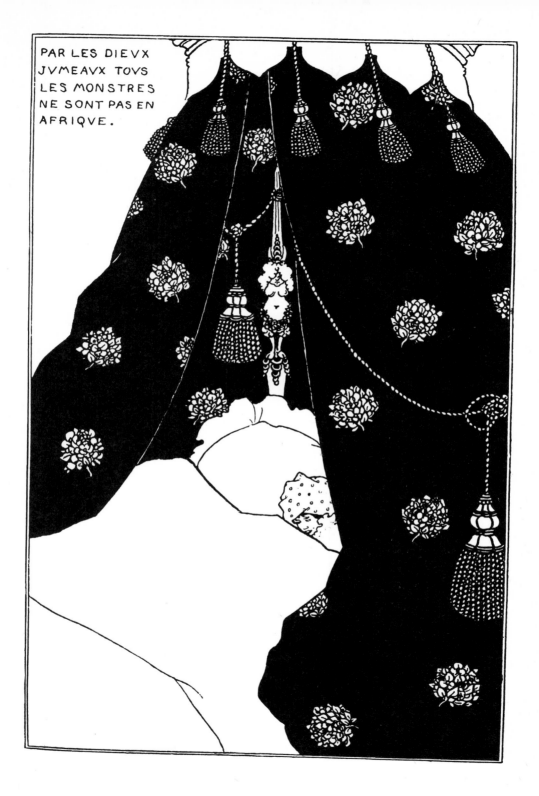

PAR LES DIEVX
JVMEAVX TOVS
LES MONSTRES
NE SONT PAS EN
AFRIQVE.

The October 1894 *Yellow Book*
(Vol. III) contained a pastel by
Albert Foschter and this picture of
Mantegna by Philip Broughton.
Both were in fact by Beardsley.

art). Beardsley then revealed that Philip Broughton was Beardsley.
The original of the 'Philip Broughton' was then bought by Bernard
Shaw.

By modern idiom it is a paradox that Beardsley's work was called
'asexual' (by *Public Opinion* in 1893) and (by *St Paul's* in 1895)
'sexless'. But in the nineties the word 'sex' still denoted sexual class,
male or female, with the implication that people should keep to their
proper stations. 'Sexless' was one of the adjectives brought against
Ibsen, whose characters were said to be 'effeminate men and male
women'. It was in that sense that the art critic of *St Paul's* described
Beardsley as 'sexless and unclean'. Beardsley's letter in reply, which he
was persuaded to withdraw before publication, said: 'As to my
uncleanliness, I do the best for it in my morning bath, and if he has
really any doubts as to my sex, he may come and see me take it.'

The fifth *Yellow Book* was in preparation when Aubrey and Mabel
Beardsley attended the first night, 14 February 1895, of *The Importance
of Being Earnest*. They were guests in the box which Wilde had secured
for his and their friend Ada Leverson, the novelist and satirist whom
Wilde, who had published a poem about the Sphinx that was one
of the wonders of the ancient world, called the Sphinx of modern life.
Ada Leverson had already attended a dress rehearsal of the play and
had arranged to publish a friendly, publicity-creating skit on it.

Wilde was forewarned that Lord Alfred Douglas's father, the
Marquess of Queensberry, intended to pursue his campaign of protest

Beardsley's design for the cover of
The Yellow Book, Vol. V. It was due
in April 1895, but the Wilde scandal
intervened and Lane banished
Beardsley from the magazine.

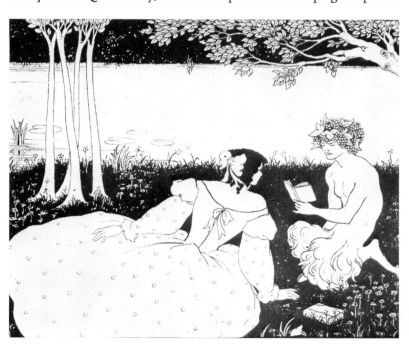

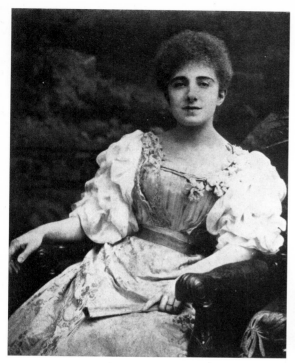

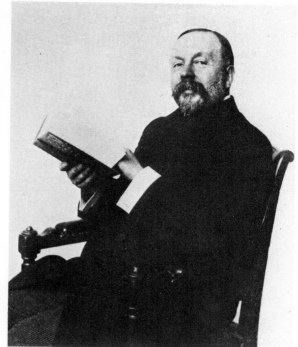

against his son's relationship with Wilde by making a disturbance at the theatre on the first night. Wilde suggested that the theatre manager tell Queensberry his ticket had been by accident booked twice (a ruse that Wilde perhaps copied from Beardsley's *contretemps* with Augustus Harris at Covent Garden). Turned away, Queensberry merely left at the theatre a bouquet of vegetables for Wilde. But four days later he left at Wilde's club the letter addressed 'To Oscar Wilde posing as a somdomite' (perhaps Queensberry had never heard the word 'sodomite' spoken and habitually misread it in his head) which provoked Wilde to his self-destructive libel action. On 5 April, thanks to the evidence Queensberry's private detectives had dug up (some of which concerned a youth once employed by Mathews and Lane) and to Wilde's own indiscreet witticisms in the witness box, Queensberry was acquitted of libel and Wilde was arrested on several charges of committing 'acts of gross indecency with another male person'.

When he left the Cadogan Hotel under arrest Wilde was carrying what was reported to be a copy of *The Yellow Book* (to which he had never contributed and which, perhaps for that reason, he said he despised). What he in fact carried was a French novel.

Lane was on his way to New York. He acted by cable. He withdrew Wilde's books from sale and, in response to demands and threats from several aggressively self-righteous (or frightened) authors on his

(*Left*) Wilde's 'Sphinx' and faithful friend, Ada Leverson. Aubrey and Mabel Beardsley attended the first night of *The Importance of Being Earnest* in her box.

(*Right*) John Lane, publisher of Wilde and Beardsley. He dropped them both when the Wilde scandal broke. Wilde named the manservant in *The Importance* after him.

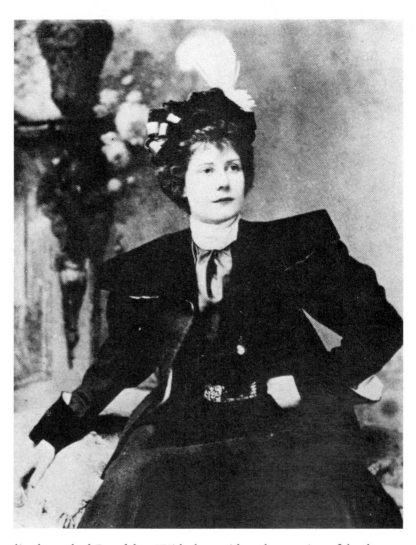

Photograph of Mabel Beardsley, aged about twenty-four. It is said to show her as Mrs Maydew in *The Queen's Proctor*, a role she created at the Royalty Theatre in 1896.

list, he sacked Beardsley. With the accidental exception of the decorations for the spine and back cover, all Beardsley's work was removed from the April 1895 *Yellow Book*.

Wilde was sentenced on 25 May to two years' hard labour. Beardsley wrote: 'I imagine it will kill him.'

THOUGH HE STILL HAD a few left-over commissions to finish off for Lane, Beardsley was suddenly without an income; and the bottom had been blown out of the market for his labour. In June he and Mabel gave up 114 Cambridge Street. Briefly he rented 57 Chester Terrace. (The 'S.W.' given as part of the address in one of his letters indicates that it was not the Nash terrace in Regent's Park.

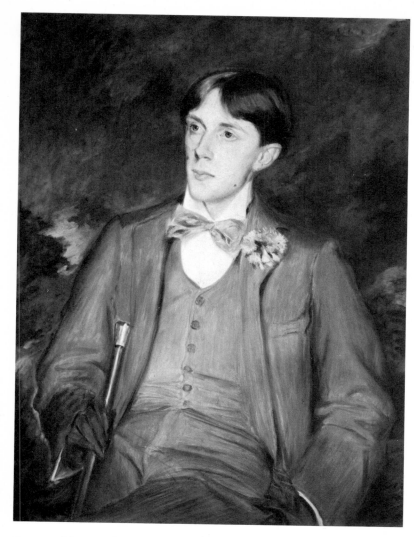

Jacques-Emile Blanche painted this portrait of Beardsley in Dieppe in summer 1895. Beardsley sent instructions to England for the framing of this and another Blanche painting for exhibition in London.

Presumably Beardsley had stuck to Pimlico and his Chester Terrace was near Chester Square.) But for the second half of 1895 and the opening of 1896 he was peripatetic. He travelled or stayed in France, Belgium and Germany, which were then cheaper countries to live in than England; and in London he took various lodgings, including, by perhaps the strangest of all his returns to the past, a set of rooms at 10–11 St James's Place that had once been occupied by Wilde.

He was at the mercy of two would-be rescuers, who fought a bizarre battle over what was left of him.

Marc-André Raffalovich, a rich Anglo-Franco-Russian in his early thirties, author of a study in French of homosexuality and of a volume of poems in English for which Beardsley designed in 1895 a

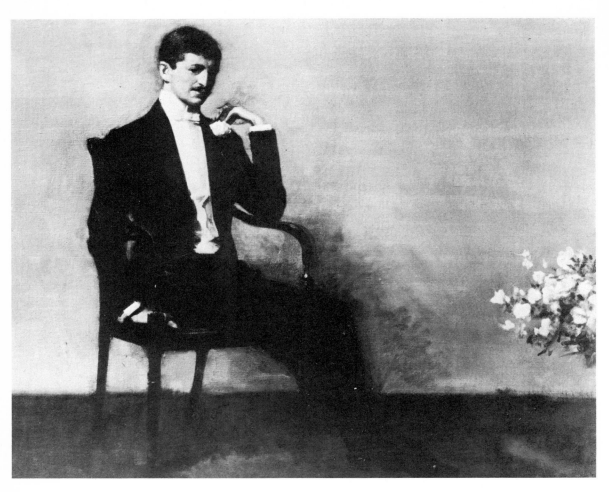

Portrait by Sydney Starr of Marc-André Raffalovich, Beardsley's 'Mentor'.

frontispiece which the publisher rejected 'because', Beardsley said, 'it contains a nude Amor', who lived in South Audley Street in a household run by his former governess and sometimes including the poet John Gray, laid siege to Beardsley with gifts of flowers, books, sonnets, chocolates, walking-sticks, opera tickets, the manuscripts of some letters he had had from George Meredith and, when he knew Beardsley well enough and Beardsley was desperate enough, £10 notes.

Beardsley was grateful, meek, polite and evasive. In their letters, Raffalovich was 'Mentor' and Beardsley 'Télémaque' – in allusion not directly to *The Odyssey* but to *Les Aventures de Télémaque*, the novel published (or, strictly, leaked by a copyist) in 1698 in which F. de S. de la Motte-Fénelon took up Homer's characters and added social morality to the tutelage that Homer's young prince Telemachos received from Mentor. Mentor was a slyly apt persona for Raffalovich, since he was a goddess in male disguise.

Photograph of Leonard Smithers, solicitor, bookseller, publisher, collector of brass pigs. When Lane dropped Beardsley from *The Yellow Book*, Smithers took him up and started *The Savoy*.

In 1896 Raffalovich was converted to Catholicism. He converted his butler and then set about converting Beardsley. Among the priests he sent to woo him was one who 'charmingly', Beardsley reported, corrected his pronunciation of the name of the author of *Télémaque*; Beardsley, unsound all his life about the accents in French words, had been saying it as 'Fénélon'.

The other contender for Beardsley's soul belonged, ideologically, to the opposite side. '*For Satan's sake*,' Beardsley wrote to him from Dieppe in 1895, '*send me de quoi vivre and quickly.*' Leonard Smithers was in his mid-thirties: a solicitor from Sheffield who had set up as a bookseller in London and lately expanded into publishing. He collected little brass pigs; 'What a joke', Beardsley wrote to him punningly, 'if all your pigs (like the statue of Pygmalion) came to life one day'; and he looked not like a real pig but like the sort of humans that humans think look like pigs. What he offered Beardsley was more welcome

(*Opposite*) *The Baron's Prayer*, from Beardsley's illustrated edition of Pope's *Rape of the Lock*, which Smithers published in 1896 and which Beardsley dedicated to Gosse.

A BOOK OF FIFTY DRAWINGS

BY

AUBREY BEARDSLEY

WITH AN ICONOGRAPHY BY AYMER VALLANCE

LEONARD SMITHERS
4 AND 5 ROYAL ARCADE, OLD BOND STREET
LONDON W
1897

Beardsley's *Puck on Pegasus* became the mascot of *The Savoy* and of Smithers's publications in general, including the volume of Beardsley drawings of which this is the title page.

(*Overleaf, left*) Beardsley's design (it was modified before publication) for the front cover of *The Savoy*, No. 1. The name of the new magazine was chosen by Mabel Beardsley.

(*Overleaf, right*) Beardsley's rococo title page for *The Savoy*, No. 1, of January 1896. It was used also in No. 2, in April.

than Raffalovich's gifts: work, pay and an exchange of sexy jokes and limericks. However, the pay seldom arrived until Beardsley had dunned him for it, and then it was often by way of postdated cheques. Beardsley presently became too ill to provide pictures on time and in quantity, and increasingly he suspected that Smithers was forced to delay publishing what he did provide by lack of capital.

Smithers's first full-scale Beardsley volume was an edition of Pope's *The Rape of the Lock* (1714) 'embroidered', as the title page said, with nine Beardsley pictures – eight lacy masterpieces and the most severely and sweetly classical cover design he ever drew. It was published in May 1896; and in July Beardsley reported with delight to Smithers that the *Morning Post*'s list of 'royal wedding presents' (for, presumably, the wedding of Princess Maud of Wales to Prince Charles of Denmark, which took place on 22 July) included a copy of a book described as '*The Rape of the Lock*, by Mrs Beardsley, illustrated by herself'. 'You see', Beardsley commented, 'how widespread is the doubt as to my sex.'

He worked on his Pope pictures simultaneously with the first stages of Smithers's other major plan, which was to pick up the art editor and, he hoped, the readership that Lane had dropped. Smithers launched a new 'illustrated quarterly', *The Savoy*, of which Arthur Symons was the literary editor. The prospectus, for which Beardsley drew a John Bull who, as George Moore noticed (too late, however, to have it expurgated), was having a very small erection beneath his very large trousers, announced the first number for Christmas 1895. Indeed, in order to appeal to the Christmas market, the first number contained a Christmas card by Beardsley. But it did not appear until January 1896. Thinner, taller (ten and a quarter inches) and cheaper (2s. 6d.) than its rival, *The Savoy* was bound in pink boards with a Beardsley design printed in black on the front. The design for the first cover was modified by Smithers; Beardsley had included a small boy pissing on a copy of *The Yellow Book*.

Three quarterly issues took *The Savoy* to July 1896. It then turned into a monthly. The *Puck on Pegasus* design which Beardsley did for the title page in July (and which he referred to as 'the little horse', perhaps because he had, in the previous autumn, 'lost my little all at the "Little Horses"' – the Petits Chevaux – at Dieppe) was repeated in all the subsequent issues, and Smithers used it on several of his book publications. However, *The Savoy* was quickly deprived of its readership. The retailers who controlled the railway bookstalls decided not to display it – an act of private censorship directed at Beardsley, though the manager, when Symons asked him to point out a Beardsley picture that was offensive, picked on one that was by William Blake. (Then Blake was illustrating an article by W. B. Yeats. Yeats told the story in a letter to a newspaper but his protest went unpublished as the editor had made it a rule not to allow mention of Beardsley's name.)

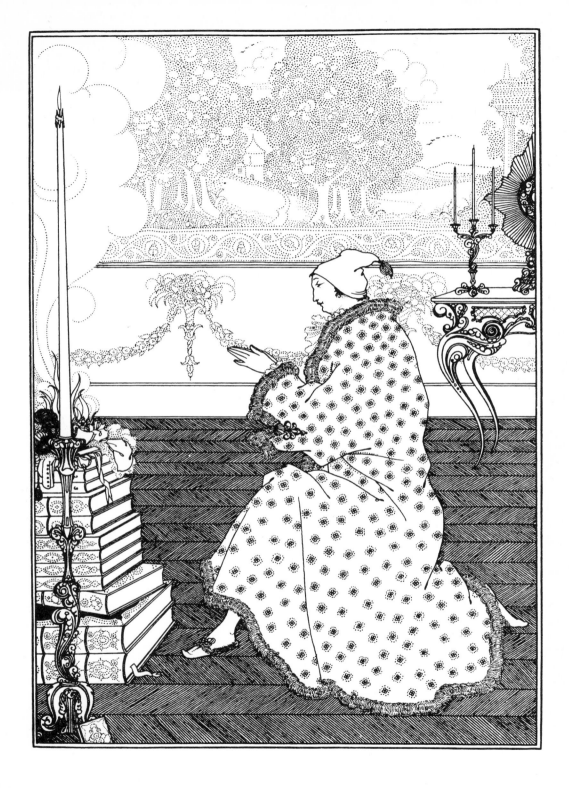

THE SAVOY

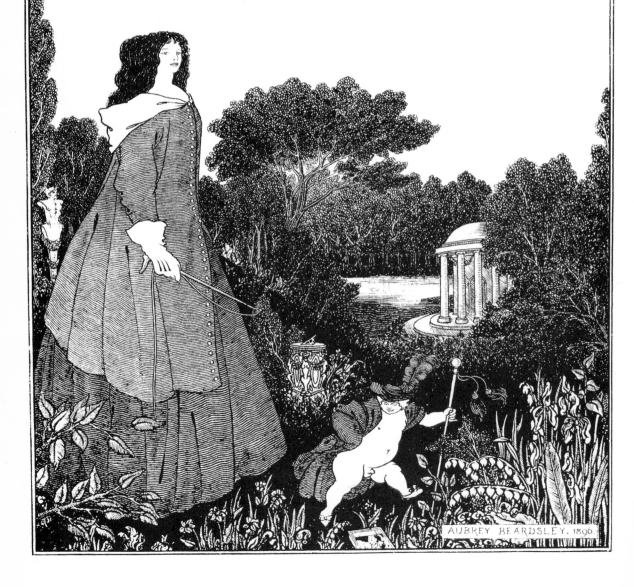

AUBREY BEARDSLEY. 1896.

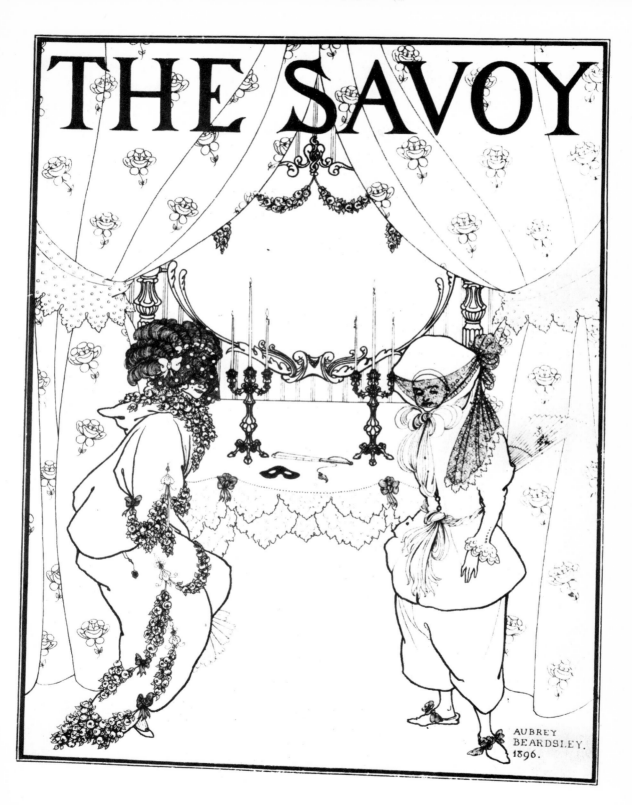

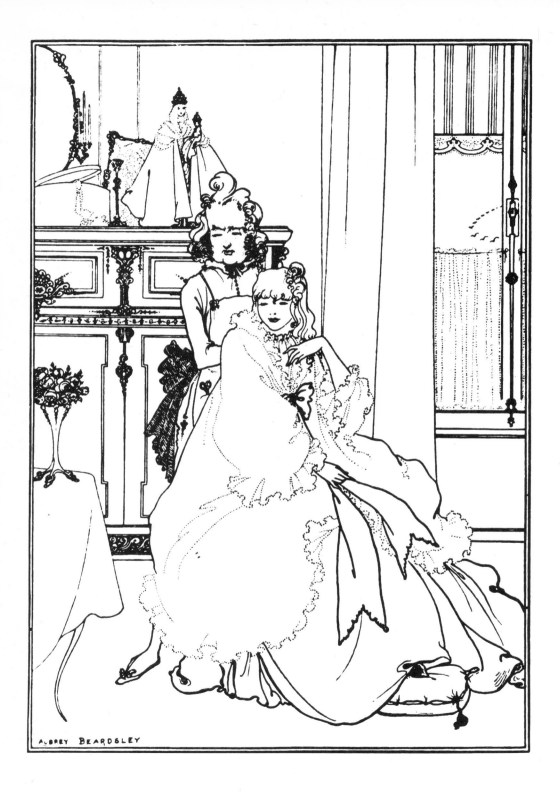

Under the Hill. (1) Köln 18... den 189 (2)

Chap. IX

"The Ballad of a barber"

Here is the tale of Carrousel
The barber of Meridian Street.
He cut & coiffed & shaved so well
That all the world was at his feet.

The King, the Queen & all the court
To no one else would trust their hair,
And reigning belles of every sort
Owed their successes to his care.

With carriage & with cabriolet
Daily Meridian Street was blocked,
Like bees about a bright bouquet
The beauty about his doorway flocked.

Such was his art he could with ease
Curl wit into the dullest face;
Or to a Goddess of old Greece
Add a new wonder & a grace.

All powders, paints, & subtle dyes,
And costliest scents that men distil,
And rare pommades, forgot their price
And marvelled at his splendid skill.

The curling irons in his hand
Almost grew quick enough to speak,
The razor was a magic wand
That understood the softest cheek.

Yet with no pride his heart was moved.
He was so modest in his ways;
It seemed his craft was all he loved
And now & then a little praise.

Beardsley wrote his poem *The Ballad of a Barber* on the paper of an hotel in Cologne.

After the issue of December 1896 Smithers killed the magazine. 'Nothing else I fear could be done with the *Savoy*,' Beardsley wrote to him.

What Beardsley had done with *The Savoy* was to develop in its pages the Beardsley rococo and carry it to the verge of the Beardsley baroque. He published in *The Savoy* his murderous *The Ballad of a Barber*, which he illustrated by an ironic silhouette that unites love and murder in one image and by a rococo picture, where the barber's face and wig resemble an eighteenth-century clock implacably telling that time is up for the young princess the barber is going to kill. (Arthur Symons found Beardsley's poem 'poor'; Beardsley suggested publishing it under the pseudonym 'Symons'.) It was also in *The*

(*Opposite*) *The Coiffing*, one of Beardsley's two illustrations to his *Ballad*. Poem and pictures were published in *The Savoy*, No. 3, July 1896.

AB.

Beardsley called this self-portrait
A Footnote. It preceded the extract
from his novel published in *The
Savoy*, No. 2.

(*Opposite*) *The Ascension of Saint Rose
of Lima*, Beardsley's illustration to a
passage of high Catholic camp in
his novel, was published in *The
Savoy*, No. 2, April 1896.

Savoy that he published many of the illustrations, including the
miraculous *Ascension of Saint Rose of Lima* (to heaven, in the maternal
and yet also erotic arms of the Madonna) which he judged 'quite one of
the best of my later drawings', to the erotic novel which he had been
writing virtually all his adult life, as well as extracts, expurgated, from
the novel itself. It is both Wagnerian (the minor character Titurel is
named after the bass in *Parsifal*) and eighteenth-century, in token of
which Beardsley kept switching its title between *Venus and Tannhäuser*
and *Under the Hill*. (It shares a venereal pun, as well as an eighteenth-

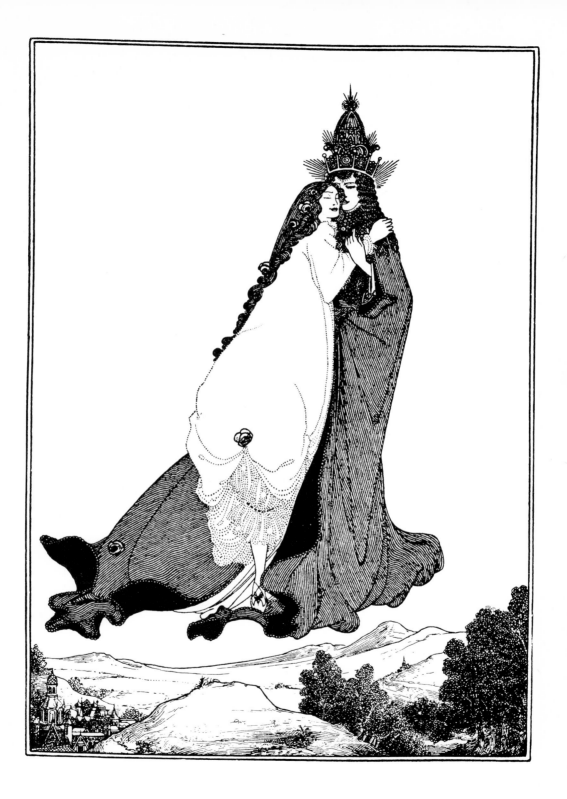

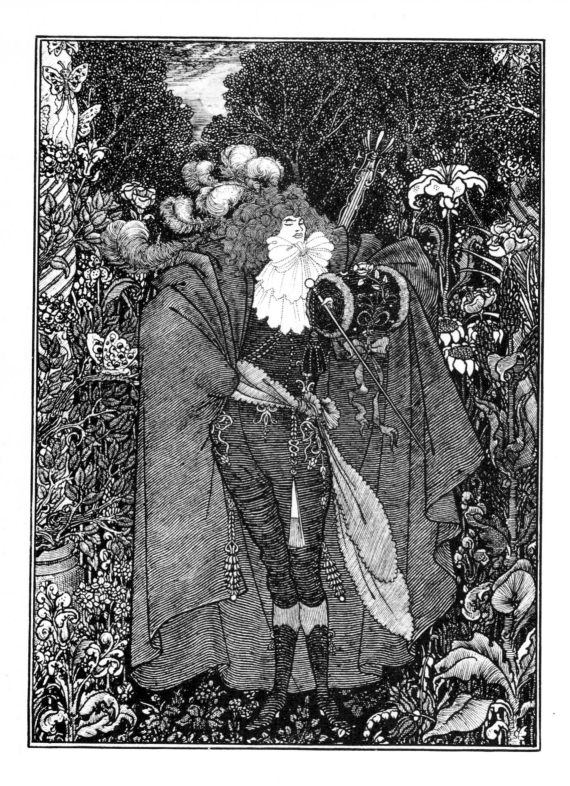

century charm of writing and lack of prurience about the pursuit of pleasure, with *Fanny Hill*.) As if the novel were a pencil drawing where he could impose one version on top of another, Beardsley changed its hero's name and style from the Abbé Aubrey to the Chevalier Tannhäuser to the Abbé Fanfreluche. He never finished the book or settled which of its versions was definitive because it was his personal erotic fantasy and to finish it would have been to relinquish life. He was his own hero, the Abbé (as he is simply called in the illustration); his initials 'A.B.', pronounced in French, say the word 'abbé'.

Much of his work for *The Savoy* Beardsley sent to Smithers from Paris, where he moved out of his hotel without paying his bill, and Brussels, where he felt so weak that he 'funked' travelling home alone and telegraphed for Mabel (who had to send Mrs Beardsley in her place) to come and 'pilot me over'. For both his health's and his finances' sake he no longer thought of a permanent household in London. In *Who's Who* he gave as his address Smithers's shop in Royal Arcade – which he privately suggested Smithers should call 'The Sodley Bed'. To raise money and as a sign that he no longer had a permanent base, he told Smithers, in his bookseller capacity, to sell his books and Japanese prints. (When they were advertised in Smithers's catalogue, Beardsley wrote, under the folklore phallic name John Thomas, offering to sell him Beardsley autographs.) In the late spring of 1896 he stayed at Crowborough, Sussex. In June 1896 he settled into 'two palatial rooms' at the Spread Eagle in Epsom, where he drew a cover and one picture for an Ali Baba volume that he never completed. He signed the cover with a prominent 'A. B.' to mark the coincidence of Ali Baba's initials with his own. He had abandoned his emblem during his work for *The Yellow Book* and thereafter signed his pictures with initials, in full, with a joke (the cover of the fifth *Savoy* was designed by 'Giulio Floriani') or, as he explained to Smithers who queried the lack on a drawing Beardsley sent him, not at all.

At Brussels he had promised to begin but not to send by post (lest, presumably, the Customs impound them as obscene) the illustrations Smithers had commissioned for a private edition (which he published in 1896) of a translation of *Lysistrata*, Aristophanes' comedy about the women of Athens going on a sex strike. The pictures, monumental as Greek vase paintings and aching with an explicit sexual frustration that was probably Beardsley's own, were drawn not at Brussels but at Epsom, where Beardsley had once drawn 'little Greenaway boys and girls' for Lady Henrietta Pelham. He worried about Raffalovich's reaction to the supposed licentiousness of his new subject matter and, as he told Smithers, slipped the information into a letter and half hoped Raffalovich would not notice.

(*Opposite*) *The Abbé*, Beardsley's picture (published in *The Savoy*, No. 1) of the hero of his novel. Pronounced in French, Beardsley's initials, A.B., say 'abbé'.

Cover for a projected book, drawn at The Spread Eagle, Epsom, 1896. By using the same lettering for both, Beardsley made another play on his initials, which are shared by Ali Baba.

Beardsley's *Frontispiece for Juvenal* made a 'double-page supplement' at the end of *The Yellow Book*, Vol. IV, January 1895.

In August 1896 he moved to a guest house, 'Pier View', at Boscombe, and began work on two illustrative projects. His last picture for *The Yellow Book* had been a frontispiece for Juvenal, in which a pair of solemnly liveried and turbaned monkeys carry a sedan chair across the pages in front of a terrace of eighteenth-century buildings. He now proposed to complete an illustrated edition of Juvenal's sixth *Satire*, for which he drew his two baroque pictures of Messalina, two spare and elegant pictures of the indelicate dancer Bathyllus, and a

(*Overleaf, left*) *Messalina Returning Home*, the earlier (1895) of Beardsley's pictures of the Roman empress and one of six pictures he drew between 1895 and 1897 in illustration of Juvenal.

(*Overleaf, right*) Beardsley's picture of the seducer Valmont, hero of Laclos's epistolary novel of 1782. Valmont is wearing a seducer's most accustomed garment, a dressing-gown.

baroque allegory of Juvenal scourging women. The translation he intended to provide himself, and he sent for a Latin dictionary. For Choderlos de Laclos's novel *Les Liaisons dangereuses*, of 1782, he chivvied Smithers to commission, urgently, a translation from Ernest Dowson (whose *The Pierrot of the Minute* Smithers published in 1897, with four decorations by Beardsley). Beardsley's sombre, classical picture of Laclos's hero, Count Valmont, appeared in the eighth and last *Savoy*.

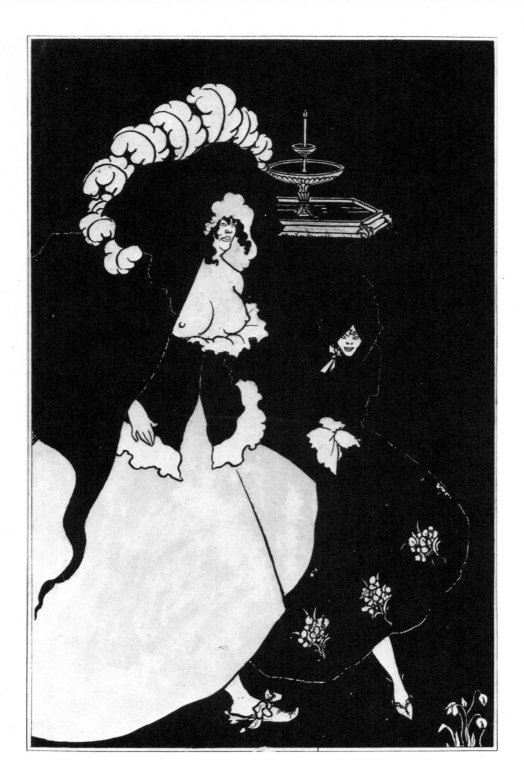

LES LIAISONS DANGEREUSES.

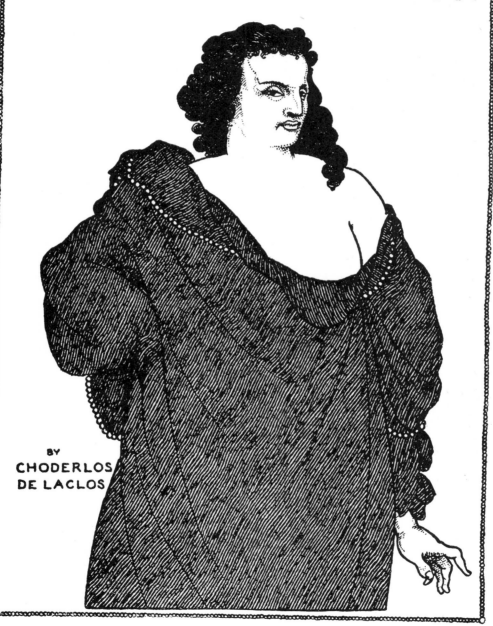

BY
CHODERLOS
DE LACLOS

However, neither project was completed to the extent Beardsley planned. Smithers, perceiving that Beardsley could no longer produce new work at his accustomed pace, decided on the retrospective volume which he published in 1897 as *A Book of Fifty Drawings by Aubrey Beardsley*. Beardsley spent much of the autumn of 1896 seeking permissions to reproduce his pictures from the previous publishers; Mabel called in person on Lane and on Dent (whom Beardsley thanked for his permission to include some of the *Morte Darthur* decorations by giving him a new drawing). At Beardsley's suggestion, Aymer Vallance, who infuriated Beardsley by his slowness, provided the new volume with an 'iconography' (which he later expanded for the Ross memoir). 'Don't', Beardsley wrote to Smithers, making explicit the intention behind his own falsifications, for public purposes, of his year of birth, 'let Vallance give the public the idea that I am forty-five and have been working for fifteen years; but give people the impression that I am two and have been working for three weeks.'

In January 1897 he moved to a guest house at Bournemouth. It was called 'Muriel'. 'I feel', he wrote to Raffalovich's friend John Gray, 'as shy of my address as a boy at school is of his Christian name when it is Ebenezer or Aubrey.' Suffering frequent haemorrhages, pursued by bills, too weak (as he explained to H. C. Pollitt, who had taken to buying the originals of some of his pictures) to dodge the bills by a sudden flit, he kept up a pious correspondence with Raffalovich, about the lives of the saints, the niceness of the priests Raffalovich sent to visit him and Raffalovich's gifts of what Beardsley described to Mabel as 'beautiful pi books', and, at the same time, a bawdy one with Smithers.

With Raffalovich (or Mentor, the female deity in disguise) and his religion, Beardsley re-worked the tension and ambivalence of his early relation to his mother. Illness reduced him to childhood: 'Such a drivelling babe have I become,' he wrote to Smithers. To Raffalovich he confessed: 'I am quite paralysed with fear.' He needed to reconcile himself to weakness and death. He did it by submitting to Raffalovich ('I *do* hope', he wrote to him, 'that I am the most grateful of creatures') and by becoming again the favourite precocious pupil, meek under the direction of governessy mother, Mentor, priests and church.

It was an autobiography that he drew, at the very end of his life, as the design for an initial *M* for his *Volpone*. The ancient-world image of the many-breasted goddess Diana of Ephesus gave him a baroque setting in which to place himself as a baby happily returning to the embrace of a multiple symbolization of M for Mother (or for Mentor).

Yet if he was to stay alive he needed to rebel against reconciliation. It was his sexy correspondence with Smithers that convinced him he was still living. 'Have had another wet dream,' he reported; and

(*Opposite*) A baroquely ornamented initial M for the projected edition of Ben Jonson's *Volpone* that Beardsley was working on at the end of his life.

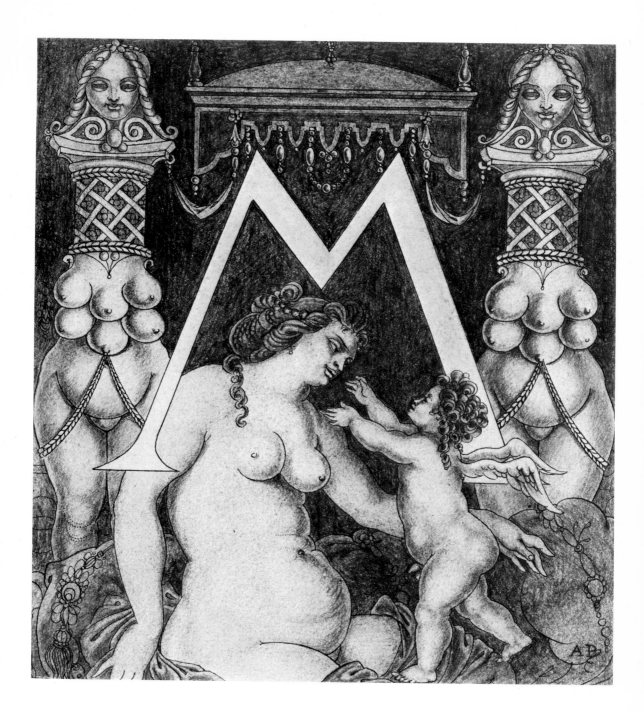

(after taking off, in one of his letters, on a flight of fetishist fancy about lace pantaloons): 'There! I've given myself a cockstand! Still!' Sometimes his anxiety obtruded through what he meant to be a pleasurable fantasy. At Boscombe he had a tooth out, under gas, and betrayed his dread of the castrating effect of his illness by sending Smithers a drawing of the removed tooth with the note: 'You see even my teeth are a little phallic.' But it was by means of Smithers that he pursued life, even if vicariously. 'Hope your adventure was entertaining,' he wrote to Smithers. 'Good old balls.'

Yet it was Raffalovich who won. In February 1897 Ellen Beardsley decided not to take a job but to stay with Aubrey, to nurse him, at Bournemouth. How the finances were to be managed Beardsley did not know. 'However I am sure it will be all right,' he wrote to Raffalovich. Delicately Raffalovich made the offer of a regular allowance, spaced out to spare Beardsley the problem of budgeting. Within a month Beardsley was received into the Catholic church.

Three days before his reception he wrote to Pollitt presaging it; 'but', he added, 'my soul has long since ceased to beat.'

In April 1897, after spending two days in a London hotel at Raffalovich's expense, Beardsley and his mother travelled to Paris under the escort of Raffalovich's doctor. 'Mother cannot abide Paris, and is utterly British over everything,' Aubrey wrote to Mabel. He moved to St-Germain, where Mabel visited him when she returned from touring in the U.S.A. He wrote to Smithers: 'I am more or less in the mortal funk of a pauper's life – and death. Would to God I had done even *one* piece of black and white work – transcendental or otherwise.'

In July he moved to Dieppe, where Smithers visited him and where they met Wilde, who had been released in May and was living in France under the name Sebastian Melmoth. Wilde reported to Ross that Smithers was 'very intoxicated but amusing' and that he hoped Beardsley would dine with him. No other publisher would now touch Wilde's work, but by September Smithers had undertaken to publish his *Ballad of Reading Gaol* and Beardsley had promised a frontispiece – 'but in a manner', Smithers wrote to Wilde, 'which immediately convinced me that he will never do it. . . . It seems hope-less to try and get any connected work out of him of any kind.'

He spent the autumn in Paris, working on his *Mademoiselle de Maupin* pictures. 'Really nothing but work amuses me at all,' he wrote to Mabel. In November he arrived, with his mother, at the Hôtel Cosmopolitain at Menton. 'The journey nearly did for me,' he told Smithers. He planned, and sent Smithers the first drawings for, his edition of *Volpone*, and he agreed to edit a new Smithers periodical (which never came into being), *The Peacock*, on condition Wilde took no part in it.

(*Opposite*) One of what he called 'the local photographs', by a Bournemouth photographer, W. J. Hawker, which Beardsley had taken while staying at 'Muriel'.

(*Overleaf, left*) The last major picture of Beardsley's life, *Volpone Adoring his Treasure*.

(*Overleaf, right*) *The Lady with the Rose*, one of Beardsley's illustrations for his projected edition of *Mademoiselle de Maupin*. A set of his six illustrations was issued posthumously in 1898.

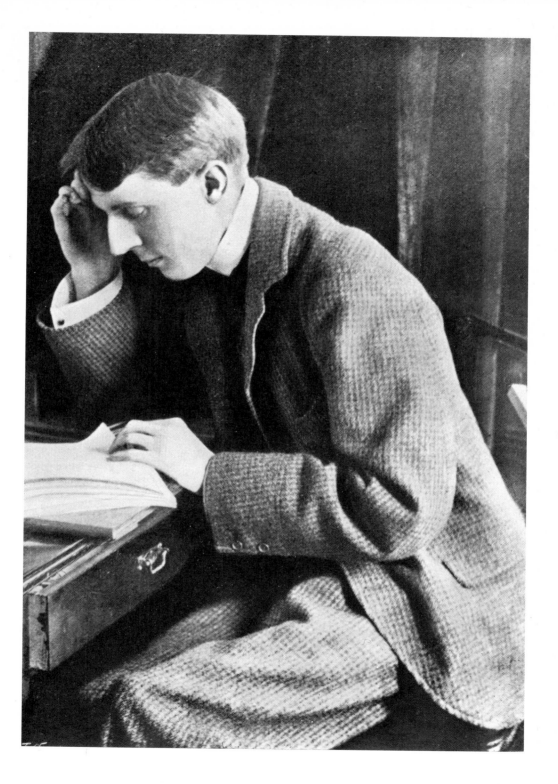

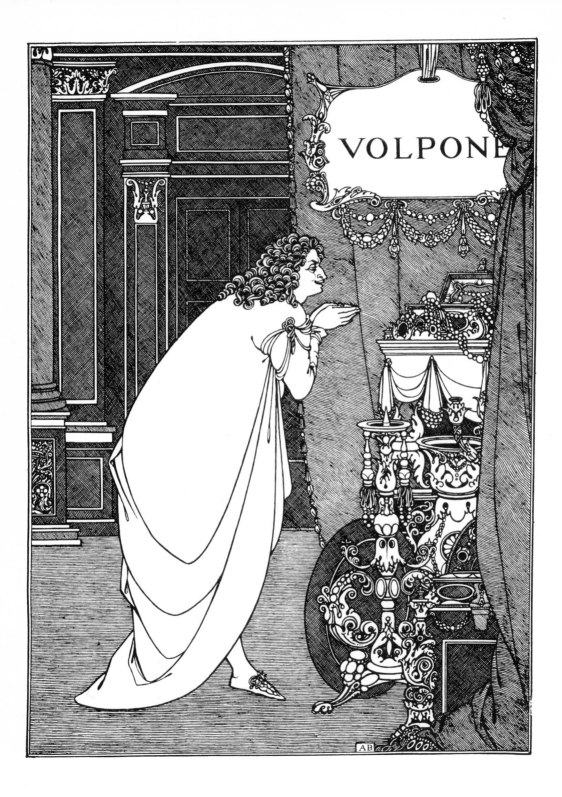

Jesus is our
Lord & Judge Menton

83

Dear Friend
 I implore you to
destroy all copies of Lysistrata
& bad drawings Show this
to Pollitt & conjure him
to do same By all
that is holy all obscene drawings

 Aubrey Beardsley

In my death agony

On 26 January 1898 he had a haemorrhage which kept him finally to his hotel room. In March Mabel Beardsley arrived at Menton. On 7 March Beardsley wrote to Smithers:

Jesus is our Lord and Judge
Dear Friend,
I implore you to destroy *all* copies of *Lysistrata* and bad drawings. Show this to Pollitt and conjure him to do same. By all that is holy *all* obscene drawings.

<div style="text-align:right">Aubrey Beardsley</div>

In my death agony.

Beardsley died on 16 March 1898, five months short of his twenty-sixth birthday. In a letter which she dated simply 'Wednesday' (16 March was indeed a Wednesday that year), Mabel Beardsley sent word to Robert Ross that Beardsley had died 'this morning very early' and that the funeral was to be 'tomorrow at nine'. The funeral consisted of a requiem mass in Menton cathedral and a procession to the hill cemetery. The register at Menton records Beardsley's age incorrectly, which makes me think that the particulars must have been supplied by Ellen Beardsley: Mabel would have been likely to get her brother's age right because, apart from three days every August, it was always exactly one year behind her own. The register also gives the date of death as the 13th, in place of the 16th implied by Mabel Beardsley's letter to Ross. I think it is the register that is likely to be wrong because, if the facts were given to the registrar orally, in French,

(*Opposite*) Beardsley's last letter to Smithers. The envelope was addressed by Beardsley's mother.

Register at Menton (photographed by Peter Ashton, who learned that the surnames were reinforced in permanent ink in 1927). It gives Beardsley's age, and probably also the date of his death, incorrectly.

by an Englishwoman, there could easily have been a confusion be-tween 'treize' and 'seize'.

There are now commemorative plaques on the house where Beardsley was born, in Buckingham Road, Brighton, and on his home at 114 Cambridge Street, Pimlico. In 1963, on the sixty-fifth anniversary of his death, there was a ceremony at his grave.

Mabel Beardsley married George Bealby Wright in 1903. She continued acting and practised literary journalism. She died of cancer in 1916. In 1919 W. B. Yeats published his sequence *Upon a Dying Lady*: ' . . . She lies, her lovely piteous head amid dull red hair Propped upon pillows. . . .'

Ellen Beardsley, Walker recorded, 'received a small Civil List Pension about 1908' and died at Haywards Heath, Sussex, in 1932.

Smithers (who died in 1907) did not destroy his edition of the *Lysistrata*. He added to his Beardsley publications by bringing out posthumously, in December 1898, *A Second Book of Fifty Drawings*.

Competing with Smithers, and capitalizing after Beardsley's death on the asset he had thrown away when he sacked Beardsley in 1895, John Lane published in 1899 a volume called *The Early Work of Aubrey Beardsley*. It contained, as Lane's advertisement put it, 'most of his work up to the time of his ceasing to be associated with the art editorship of "The Yellow Book"' – most of his work, that was, in which the rights belonged to Lane, not Smithers.

However, in 1900 Smithers went bankrupt. Lane took over the Beardsley volumes under Smithers's imprint, and, having acquired the rights, was able to produce in 1901 a companion piece to his own anthology: *The Later Work of Aubrey Beardsley*. He advertised both his own and Smithers's (which had now become his) Beardsley volumes in the Ross memoir which he published in 1909.

In 1906 Bernard Shaw put a shadow of Beardsley on the stage. The dilemma in *The Doctor's Dilemma* is whether a doctor who had it in his power to cure a limited number of tuberculosis patients ought to include in those he rescued a great draughtsman who is also a villain. Shaw did not muddle the dramatic issue by attributing to his fictitious artist what he perhaps thought of as Beardsley's villainy, namely the eroticism of his drawings. His Louis Dubedat, who dies of consumption at twenty-three, is villainous about money – a trait perhaps borrowed from Smithers. Shaw, whose note that he was not taken in by Beardsley's pose as vicious was written on the flyleaf of his copy of the Beardsley *Morte Darthur*, left in his play a trace of his chain of association, Dubedat–Beardsley–the story of Arthur and Guinevere. He called Dubedat's wife Jennifer – a name that must have been still unusual in 1906 since he has her explain that it is only the Cornish form of 'what you call Guinevere'.

(Opposite) Beardsley's grave in the hill cemetery (now called the old cemetery) at Menton. A Catholic, he was assigned a Protestant grave in the English section of the cemetery.

ACKNOWLEDGMENTS

I am grateful to D. R. Grimes, LLB, MBIM, Town Clerk and Chief Executive, Epsom and Ewell, and to M. L. Allardyce, Branch Librarian, Epsom Library, whose helpful answers to my questions enabled me to identify for the first time where Beardsley lived, as a boy, in Epsom; to P. W. Rogers, MC, MA, Headmaster of Brighton, Hove and Sussex Grammar School, whose kind reply to my enquiry confirmed the whereabouts of Brighton Grammar School when Beardsley attended it and established for the first time who paid his school fees there; to my fellow admirer of and writer about Beardsley, Derek Stanford, for lending me his copy of a vital book; and to my fellow author Maureen Duffy for leading me to previously unknown documents that establish for the first time the identity of the great-aunt with whom Beardsley lived during his childhood.

B.B.

1872 21 August: Birth of Aubrey Vincent Beardsley, second child and only son of Vincent and Ellen Agnus (*née* Pitt) Beardsley, at 31 (then numbered 12) Buckingham Road, Brighton, the home of A B's maternal grandfather, Surgeon-Major William Pitt. A B's sister, Mabel Beardsley, had been born on 24 August 1871.

1879 September: A B, already showing signs of tuberculosis, becomes boarder at preparatory school for boys, Hamilton Lodge, Hurstpierpoint, Sussex.

1881 (probable date) A B, probably with his family, goes to live at 35 or 37 Ashley Road, Epsom, where he executes commissions for Lady Henrietta Pelham.

1883 (probable date) After a short period in London, Aubrey and Mabel Beardsley go to live at 21 Lower Rock Gardens, Brighton, with their maternal great-aunt, Sarah Pitt.

1884 September: A B goes to Brighton Grammar School (then situated in Buckingham Road). His school fees are paid by Sarah Pitt.

1887 October: Death of A B's maternal grandfather, William Pitt.

1888 summer: A B leaves school and takes temporary job as clerk in District Surveyor's Office, Clerkenwell and Islington, London.

1889 1 January: A B begins work as clerk at Guardian Life and Fire Insurance Office, Lombard Street, London. Lives in lodgings with his family in Pimlico. Christmas: bad haemorrhages.

1890 4 January: A B's first professional publication (journalism).

1891 12 July: Aubrey and Mabel Beardsley call on Edward (later Sir Edward) Burne-Jones and meet Oscar and Constance Wilde. As a result of E B-J's praise and advice, A B starts attending evening classes at the Westminster School of Art.

3 December: Death of Sarah Pitt. 25 December: Publication (in November issue) of A B's drawing *Hamlet Patris Manem Sequitur* in *The Bee*, magazine of Blackburn Technical Institute.

1892 14 February: Through Aymer Vallance (who fails to get A B a commission from William Morris) A B meets Robert Ross. June: A B uses annual holiday from office to make first visit to Paris, where he meets Puvis de Chavannes. Autumn: A B secures commission from J. M. Dent for illustrated edition of *Le Morte Darthur* and gives up both art school and clerkship.

1893 February: *Pall Mall Budget* begins publishing drawings by A B. April: First issue of *The Studio* contains Joseph Pennell's article in praise of A B, illustrated by examples of A B's pictures, including first version (illustrating French text of Wilde's play) of Salomé kissing the severed head. May: A B visits Paris with Pennell. Summer: Aubrey and Mabel Beardsley set up house at 114 Cambridge Street, Pimlico. August: on becoming twenty-one, A B inherits £500 from Sarah Pitt. During 1893–4 J. M. Dent publishes both *Le Morte Darthur*, with A B's illustrations, and three volumes of *Bon-Mots* decorated with 'grotesques' by A B.

1894 1 January: A B and Henry Harland conceive *The Yellow Book*. February: John Lane and Elkin Mathews publish the English translation of Oscar Wilde's *Salome* with illustrations by A B. April: Volume I of *The Yellow Book* published under the art editorship of A B, literary editorship of Harland and imprint of Mathews and Lane at the Bodley Head. July: Publication of Volume II of *The Yellow Book*. October: Publication of Volume III of *The Yellow Book*. Of Volume III and all later volumes Lane is the sole publisher. Besides his pictures in *The Yellow Book*, A B's work includes his poster for the Florence Farr season at the Avenue Theatre, his decorations for the *Keynotes* series for Lane (published 1893–5) and his Poe illustrations (published 1894–5).

1895 January: Publication of Volume IV of *The Yellow Book*. April: Arrest of Oscar Wilde; Lane removes A B's pictures from Volume V (April) of *The Yellow Book* and sacks A B from art editorship. May: Wilde sentenced to two years' hard labour; publisher David Nutt rejects A B's frontispiece to *The Thread and the Path*, poems by André Raffalovich. June: Aubrey and Mabel Beardsley give up 114 Cambridge Street. A B moves out in July and lodges at 57 Chester Terrace and then (between visits to Dieppe) at 10–11 St James's Place. He finishes work commissioned by Lane and prepares work for his new publisher, Leonard Smithers.

1896 January: Publication of No. 1 of *The Savoy*, an illustrated quarterly; art editor is A B, literary editor Arthur Symons, and publisher Leonard Smithers. February–March: A B in Paris and Brussels. April: Publication of *The Savoy*, No. 2. May: Publi-

cation of Smithers's edition of *The Rape of the Lock*, illustrated by A B; A B is briefly in London (in rooms at 17 Campden Grove) and then moves to Crowborough. June: A B at The Spread Eagle, Epsom. July: Publication of *The Savoy*, No. 3. August: Publication of No. 4 of *The Savoy*, which from now on is a monthly; A B moves to 'Pier View', Boscombe. Autumn: Publication of Smithers's limited edition of translation of Aristophanes' *Lysistrata*, illustrated by A B. December: Publication of eighth and last number of *The Savoy*.

1897 January: A B moves to 'Muriel', Bournemouth. February: André Raffalovich makes A B a regular allowance. March: A B received into Roman Catholic church. April: accompanied by his mother, A B travels to Paris and then moves on to St-Germain. July: A B moves to Dieppe, where he meets Wilde. November: A B moves, with his mother, to Hôtel Cosmopolitan, Menton.

1898 January: after a haemorrhage, A B is confined to his hotel room. March: Mabel Beardsley arrives in Menton. On 16 March Aubrey Beardsley dies.

SELECT BIBLIOGRAPHY

WORKS BY AUBREY
BEARDSLEY OR
ILLUSTRATED BY HIM

Aubrey Beardsley *The Story of Venus and Tannhäuser, A Romantic Novel*, London and New York 1967
Aristophanes *Lysistrata*, translated by Samuel Smith and illustrated by Aubrey Beardsley, London 1970 (facsimile of Leonard Smithers edition of 1896)
A Book of Fifty Drawings by Aubrey Beardsley, with an iconography by Aymer Vallance, published by Leonard Smithers, London 1897
The Early Works of Aubrey Beardsley, with a prefatory note by H.C. Marillier, New York 1967, reprint, with some alterations, of John Lane revised edition, London 1920 (original John Lane edition 1899)
The Later Works of Aubrey Beardsley, New York 1967, reprint, with some alterations, of John Lane revised edition, London 1930 (original John Lane edition 1901)
Robert Ross *Aubrey Beardsley*, with a revised iconography by Aymer Vallance, published by John Lane, The Bodley Head, London 1909
The Savoy, Nos. 1–8, 1896
A Second Book of Fifty Drawings by Aubrey Beardsley, with a prefatory note by Leonard Smithers, published by Leonard Smithers, London 1898

R.A. Walker (selected and edited) *A Beardsley Miscellany*, London 1949
The Yellow Book, Vols. I–IV, April 1894–January 1895

GENERAL WORKS

Henry Maas, J.L. Duncan and W.G. Good (edited) *The Letters of Aubrey Beardsley*, London 1971
Brian Reade (edited) *Beardsley*, London 1967
Brian Reade and Frank Dickinson (edited) *Aubrey Beardsley*, catalogue of exhibition at the Victoria and Albert Museum, London 1966
Derek Stanford (introduced and selected) *Aubrey Beardsley's Erotic Universe*, London 1967

RELATED WORKS

Lord Alfred Douglas *Oscar Wilde and Myself*, London 1914 (edition of 1919)
Rupert Hart-Davis (edited) *The Letters of Oscar Wilde*, London 1962
Richard Le Gallienne *The Romantic 90's*, London and New York 1926
Clifford Musgrave *Royal Pavilion: An Episode in the Romantic*, London 1959
Henry D. Roberts *A History of the Royal Pavilion, Brighton*, London 1939
W.B. Yeats *Autobiographies*, London 1955

44 The Grosvenor Gallery of Fine Art, New Bond Street. Engraving from *The Illustrated London News*, 5 May 1877. *Photo The Illustrated London News.*

45 Caricature of J. M. Whistler, *c.* 1893–4. Ink. *National Gallery of Art, Washington. Rosenwald Collection.*

46 The Grange, North End Road, Fulham, house of Edward Burne-Jones. Photo National Monuments Record.

Oscar Wilde. Photograph by W. and D. Downy, *c.* 1891. *National Portrait Gallery, London.*

47 Drawing of Professor Fred Brown, 1892. Pen, pencil and ink. *Tate Gallery, London.*

48 *Masked Woman with a White Mouse, c.* 1894. Oil on canvas. *Tate Gallery, London.*

49 Aubrey Beardsley, photographed by Frederick Hollyer. Photo Radio Times Hulton Picture Library.

51 The drawing-room of The Grange. Photo National Monuments Record.

53 *Siegfried, Act II, c.* 1892–4. By courtesy of the Victoria and Albert Museum.

55 *Raphael Sanzio, c.* 1892. Ink drawing. *Princeton University Library.*

Vignette in *Bon-Mots* of Charles Lamb and Douglas Jerrold, edited by W. Jerrold, 1894.

Vignette in *Bon-Mots* of Sydney Smith and R. Brinsley Sheridan, edited by W. Jerrold, 1893.

56 Self-portrait, *c.* 1892. *Courtesy of the Trustees of the British Museum.*

57 Carl Maria von Weber, *c.* 1892. *Princeton University Library.*

W. R. Sickert, *Portrait of Aubrey Beardsley.* Oil on canvas. *Tate Gallery, London.*

58 *Hamlet Patris Manem Sequitur,* 1891. Pencil. *Courtesy of the Trustees of the British Museum.*

59 Robert Ross. Photo courtesy of Professor Giles Robertson.

60 *Le Dèbris* (sic) *d'un Poète, c.* 1892. Pen, Indian ink and wash. By courtesy of the Victoria and Albert Museum.

61 Aubrey Beardsley. Photograph by Frederick H. Evans. By courtesy of the Victoria and Albert Museum.

62 Chapter-heading of Chapter III, Book XIV of *Le Morte Darthur,* 1893–4. From the collection of R. A. Harari, O.B.E., now in the Victoria and Albert Museum.

Initial page to Chapter I, Book II of *Le Morte Darthur,* 1893–4. *British Library.*

63 *How Morgan Le Fay gave a shield to Sir Tristram.* Drawing for a full-page illustration in Chapter XL, Book IX of *Le Morte Darthur,* 1893–4. *Fitzwilliam Museum, Cambridge.*

Design for the chapter-heading of Chapter XIV, Book I of *Le Morte Darthur,* 1893–4. *Rosenwald Collection, Library of Congress, Washington.*

64 Caricature of Queen Victoria as a ballet dancer, 1893. Indian ink and pencil. By courtesy of the Victoria and Albert Museum.

65 Cover of the first issue of *The Studio,* Vol. I, No. 1, April 1893.

66 *J'ai baisé ta bouche Iokanaan.* Indian ink and green watercolour wash. Published in *The Studio,* Vol. I, No. 1, April 1893. *Princeton University Library.*

67 *The Wagnerites.* Indian ink touched with white. Published in *The Yellow Book*, Vol. III, October 1894. By courtesy of the Victoria and Albert Museum.

Sketch of Joseph Pennell as 'the devil of Notre Dame'. From *The Early Work of Aubrey Beardsley*, 1899.

68 Design for the frontispiece to *Pastor Sang* by Björnstjerne Björnson, 1893.

69 114 Cambridge Street, Pimlico. Photo Eileen Tweedy.

The Spread Eagle Hotel, Epsom. Photo Eileen Tweedy.

70 Oscar Wilde with Lord Alfred Douglas. Photo Radio Times Hulton Picture Library.

72 *The Eyes of Herod*, c. 1894. Pen and black ink on white paper. *Courtesy of the Fogg Art Museum, Harvard University. Bequest of Grenville L. Winthrop.*

73 *The Climax*, 1894. Illustration from *Salome* by Oscar Wilde.

74 Mrs Patrick Campbell. From *The Yellow Book*, Plate X, Vol. I, April 1894.

75 Sketch portrait of Henry Harland. From *The Early Work of Aubrey Beardsley*, 1899.

Design for the front cover of *The Yellow Book*, Vol. I, April 1894. *Tate Gallery, London.*

76 *The Fat Woman*, c. 1894. Indian ink and wash. *Tate Gallery, London.*

Portrait of Henry James by John S. Sargent. From *The Yellow Book*, Vol. II, July 1894. By courtesy of the Victoria and Albert Museum.

77 *The Murders in the Rue Morgue.* Illustration to *The Works of Edgar Allan Poe*, 1894–5.

78 Design for the invitation card to the opening of Prince's Ladies Golf Club at Mitcham, Surrey, 16 July 1894.

Design for frontispiece to *Plays* by John Davidson, 1894. Indian ink over pencil. *Tate Gallery, London.*

79 *The Black Cat.* Illustration to *The Works of Edgar Allan Poe*, 1894–5.

80 Designs for key monograms for volumes in the Keynotes series. From *The Early Works of Aubrey Beardsley*, 1899. *British Library.*

81 Poster for John Todhunter's play, *A Comedy of Sighs*. Colour lithograph, 1894. By courtesy of the Victoria and Albert Museum.

82 Poster advertising Singer sewing machines. From *The Poster*, Vol. I, October 1898. By courtesy of the Victoria and Albert Museum.

83 Self-portrait. From *The Yellow Book*, Vol. III, October 1894.

84 Portrait of Mantegna by Philip Broughton (Aubrey Beardsley). From *The Yellow Book*, Vol. III, October 1894. By courtesy of the Victoria and Albert Museum.

Design for the cover of Vol. V of *The Yellow Book*, due to be published in April 1895. The Royal Pavilion, Art Gallery and Museums, Brighton.

85 Ada Leverson. Photo by kind permission of Violet Wyndham, the writer.

John Lane. From J. Lewis May, *John Lane and the Nineties*, 1936. *The Bodley Head Ltd.*

86 Mabel Beardsley, c. 1896. Photograph by Messrs Alfred Ellis and Walery. By courtesy of the Victoria and Albert Museum.

87 Aubrey Beardsley by J. E. Blanche, 1895. Oil on canvas. *National Portrait Gallery, London.*

88 Portrait of Marc-André Raffalovich by Sydney Starr. The Trustees of the National Library of Scotland. Photo Tom Scott.

89 Leonard Smithers. From *Letters from Aubrey Beardsley to Leonard Smithers, 1937.*

90 *Puck on Pegasus*, title page to *A Book of Fifty Drawings, 1897.*

91 *The Baron's Prayer.* Drawing for Alexander Pope's *Rape of the Lock, 1896. Courtesy of the Fogg Art Museum, Harvard University. Scofield Thayer Collection.*

92 Cover design (modified before publication) for *The Savoy*, No. 1, January 1896. *Courtesy of the Fogg Art Museum, Harvard University. Bequest of Grenville L. Winthrop.*

93 Drawing for the title page of *The Savoy*, No. 1, January 1896. *Courtesy of the Fogg Art Museum, Harvard University. Bequest of Grenville L. Winthrop.*

94 *The Coiffing*, illustrating Beardsley's poem *The Ballad of a Barber.* From *The Savoy*, No. 3, July 1896.

95 Chapter IX of *The Ballad of a Barber*, written on hotel notepaper. *The Bodley Head Ltd.*

96 *A Footnote.* From *The Savoy*, No. 2, April 1896. *British Library.*

97 *The Ascension of Saint Rose of Lima.* Illustration to Beardsley's novel, *Under the Hill*, and published in *The Savoy*, No. 2, April 1896.

98 *The Abbé.* Illustration to Beardsley's *Under the Hill* and published in *The Savoy*, No. 1, January 1896. From the collection of R. A. Harari, O.B.E., now in the Victoria and Albert Museum.

99 *Ali Baba.* Cover design for *The Forty Thieves. Courtesy of the Fogg Art Museum, Harvard University. Bequest of Grenville L. Winthrop.*

100, *Frontispiece for Juvenal.* Double-page
101 supplement from *The Yellow Book*, Vol. IV, January 1895. By courtesy of the Victoria and Albert Museum.

102 *Messalina Returning Home, 1895. Tate Gallery, London.*

103 *Count Valmont.* Illustration to *Les Liaisons dangereuses* by Choderlos de Laclos. From *The Savoy*, No. 8, December 1896. *British Library.*

105 *Initial M, Fertility*, for Beardsley's projected edition of *Volpone.* Pen, ink and grey wash. *Courtesy of the Fogg Art Museum, Harvard University. Bequest of Grenville L. Winthrop.*

107 Aubrey Beardsley in his room in Bournemouth. Photograph by W. J. Hawker. From *A Second Book of Fifty Drawings, 1899.*

108 *Volpone Adoring his Treasure.* Drawing from the frontispiece to *Ben Jonson: His Volpone; or the Foxe, 1898. Princeton University Library.*

109 *The Lady with the Rose.* The fifth in the series, *Six Drawings Illustrating Théophile Gautier's Romance, Mademoiselle de Maupin, 1898.* Pen, ink and wash. *Courtesy of the Fogg Art Museum, Harvard University, Scofield Thayer Collection.*

110 Letter from Beardsley to Leonard Smithers, 7 March 1898. *Henry E. Huntingdon Library and Art Gallery.*

111 Aubrey Beardsley's entry in the Register of Deaths, Menton. Photo Peter Ashton.

113 Aubrey Beardsley's grave in the Arabuques Cemetery, Menton. Photo Peter Ashton.

INDEX